IMAGES
of America

TASHMOO PARK AND
THE STEAMER *TASHMOO*

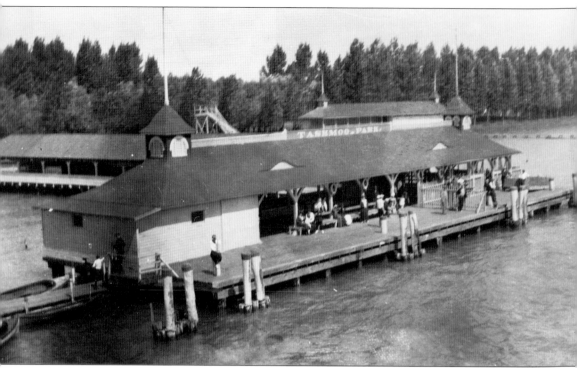

WAITING FOR THE STEAMER. This photograph, dated 1915, was taken from the deck of the steamer *Tashmoo* as she approached the landing at Tashmoo Park. The shed at the end of the wharf shares the same distinctive architectural style carried by all the park's major buildings. The steamer will soon tie up and begin unloading passengers that are looking forward to an enjoyable day at the park. (Courtesy of Steffke Memorial Maritime Collection).

ON THE COVER: ON THE WAY TO TASHMOO PARK. Here, the steamer *Tashmoo* is seen entering the US Ship canal. This image, which dates from 1900, the steamer's first season, made a picture-perfect view. This photograph, known as "The *Tashmoo* with the Man and His Hat," is without question the most common picture reproduced of the *Tashmoo* and is found in many media, including photographs, postcards, and especially the early color Phostint postcards coveted by collectors today. (Courtesy of Detroit Publishing Company, Library of Congress.)

IMAGES
of America

TASHMOO PARK AND
THE STEAMER TASHMOO

Arthur M. Woodford

ARCADIA
PUBLISHING

Published by Arcadia Publishing
Charleston, South Carolina

Printed in the United States of America

Library of Congress Control Number: 2011940172

For all general information, please contact Arcadia Publishing:
Telephone 843-853-2070
Fax 843-853-0044
E-mail sales@arcadiapublishing.com
For customer service and orders:
Toll-Free 1-888-313-2665

Visit us on the Internet at www.arcadiapublishing.com

*This book is dedicated to my wife, Mary Rose, who has
made for us a wonderful home where Tashmoo Park
once stood and the steamer Tashmoo once docked.*

CONTENTS

ACKNOWLEDGMENTS

When writing a book of this type, the author is always dependent on many others. Keith Steffke, one of our region's most knowledgeable marine historians, has one of the finest private archives of Great Lakes maritime history in our state, including most of the images of the steamer *Tashmoo*. He also provided historically accurate and detailed text for pictures. The images from his collection are shown as Steffke Memorial Maritime Collection (SMM Collection). Michele Komar provided similar assistance as she is a most knowledgeable person concerning the life and times of Tashmoo Park. Longtime island resident Gary Grout, one of the first to introduce me to the history of the park and steamer, was the first president of our new Harsens Island St. Clair Flats Historical Society, and a portion of the revenue from every copy of this book sold will be donated to the society.

Special thank-yous go to Mark Bowden, coordinator of special collections, Burton Historical Collection, Detroit Public Library; Joan Bulley of the Algonac/Clay Township Historical Society; Elizabeth M. Clemens, audiovisual archivist, Reuther Library, Wayne State University; Carol Fink of the Rare Book Room, Library of Michigan, an agency of the Michigan Department of Education; Joel Stone, curator of the Dossin Great Lakes Museum, Detroit Historical Society; Sandy Thaxton, head of reference, Mary Lou Johnson–Hardin County Library, Kenton, Ohio; and Alyn Thomas, curator of the Manning Brothers Collection, Detroit.

I also wish to recognize Michael Dixon. As author of many books about the history of Harsens Island and the St. Clair Flats, he is always gracious in sharing his knowledge. Erik Hall kindly allowed me the use of his fine collection. Special thanks also go out to Susan and Bob Bryson, the owners of Tashmoo Marina. Others I wish to thank include Chuck Brockman, Barb Crown, Jean Dodenhoff, John and Marie Eidt, Bob Kowalski, Bernard and Nancy Licata, Patrick Livingston, Dave Miramati, Jean Nelson, Denne and Peggy Osgood, John Polacsek, Ruth and Ken Roth, Paul and Judy Wargo, Gerald Waters, William Worden, and, of course, Peter J. Durand.

Finally, I wish to thank my wife, Mary Rose Woodford.

INTRODUCTION

Located at the top of Lake St. Clair at the mouth of the St. Clair River, Harsens Island forms part of the largest freshwater delta in the United States. Only an hour's drive from Detroit, the island is accessed by a short ferry ride from the city of Algonac, Michigan, on the mainland. To the south of Harsens Island is the region historically known as the St. Clair Flats, commonly known locally as simply the "Flats," and today, these two areas together are known as Harsens Island.

The island, including the Flats, covers about 7,000 acres, most of which is protected wildlife refuge and marshland managed by the Michigan Department of Natural Resources. Generations of families have come to the island over the years, either as summer visitors or full-time residents. Today, Harsens Island has 1,200 full-time residents; however, from Memorial Day to Labor Day, that number swells to more than 5,000 as summer residents come back to their cottages.

The island was first settled in 1778 by Jacob Harsen, who bought the land from the Chippewa Indians. Originally a farming community, the island became known as a resort community and the "Venice of America" during the latter part of the 19th century when Detroiters came to stay at one of the island's many clubs or hotels. Traveling by excursion steamers, such as the *Tashmoo*, visitors also came to the island's Tashmoo Park, which opened in 1897.

The park was owned and operated by the White Star Line steamship company of Detroit. In its heyday, 250,000 people visited the park annually, arriving aboard one of the many excursion steamers out of Detroit, the most famous of which was, without question, the White Star Line's *Tashmoo*. With the park only 27 miles from Detroit's waterfront, families could enjoy a pleasant two-hour boat ride up the Detroit River, across Lake St. Clair, and then up the south channel of the St. Clair River to the park.

At the 60-acre park, visitors would picnic, play baseball, enjoy the swings and merry-go-round, dance at the pavilion, ride bicycles on a cinder track, and at the water's edge, enjoy swimming and boating. Visitors to the park could also purchase souvenirs, the most popular of which were made by Indians from the Walpole Island reservation, which was opposite the park across the St. Clair River in Ontario, Canada.

The magnificent steamer *Tashmoo* was launched in 1899 and began service to the park in the summer of 1900. She was designed by the noted marine architect Frank E. Kirby and built by the Detroit Shipbuilding Company. The steamer, which was 320 feet in length overall, could accommodate 2,800 passengers. In 1901, the *Tashmoo* (representing the city of Detroit) competed with Cleveland's famed steamer the *City of Erie* on a nearly 100-mile race on Lake Erie. Sadly, the *Tashmoo*, thought to be the faster boat, finished 45 seconds behind her rival. The following year, Pres. Theodore Roosevelt traveled on the *Tashmoo* during a trip on the Detroit River. Earlier, on another occasion, the *Tashmoo* was host to Admiral Dewey, the victor of the Battle of Manila Bay, and led a celebration parade up the Detroit River.

In this book—in pictures and in words—is the story of Tashmoo Park and the steamer *Tashmoo*. The story begins with the first steamers to sail up the St. Clair River from Detroit to Port Huron. There was really no regular service until the 1870s and 1880s, with the growth of clubs and hotels at the Flats and Harsens Island. The Old Club, the Rushmere, the Star Island House, Joe Bedore's, and the Grand Pointe were only a few of the stops made by the steamers. By the late 1890s, visitors to the Flats became so numerous, the steamship companies began to promote picnic grounds for their passengers and then amusement parks, like the famed Tashmoo Park.

The steamer *Tashmoo* began trips to the Flats and Harsens Island in June 1900. It provided a wonderful excursion that allowed city-dwellers to escape the summer heat and visit a resort community with a stop for a special fish or frog legs dinner at one of the hotels or a enjoy a fun-filled day at Tashmoo Park.

The steamer was a safe boat. Never in her career was there a loss of life nor, until the end, did she ever have a serious accident. She did, however, experience a number of interesting incidents. In 1927, she broke loose from her winter anchorage on the Detroit River and crashed into the Belle Isle Bridge. Then, in 1934, while going to pick up passengers at the park, she damaged a paddle wheel and had to be towed to dry dock for repairs.

On June 18, 1936, near Sugar Island on the lower Detroit River, her hull was damaged by a large submerged boulder, and the steamer sank at the dock at Amherstburg, Ontario, in 18 feet of water. Attempts were made to salvage the steamer, but without success. The *Tashmoo* would never sail again.

After the sinking of the *Tashmoo*, efforts were made to keep the park operating. However, the effects of the Depression, World War II, and the automobile were too great to overcome, and the park was closed in 1951. Today, the park property has been turned into a marina for the care and storage of yachts and sailboats.

A question that is commonly raised when talking about either the park or the steamer is "What is the meaning of the word *Tashmoo*?" The answer is that no one knows for certain. Many local residents say it means "sweet water." Others suggest "resting place," and a newspaper article dated August 1898, before the steamer was built, claims the word means "happy thoughts." All agree it is Native American in derivation, but none agree as to the meaning. We do have a good idea, however, where the name came from. One of the original founders of the White Star Line and a longtime member of its board of directors, John Pridgeon Jr. was long active in Detroit's maritime affairs, serving as mayor of the city from 1888 to 1890.

For many years, Pridgeon and his family spent their summers on Martha's Vineyard, long before there was any Tashmoo Park or steamer. On the north coast of Martha's Vineyard, near the present-day town of Vineyard Haven, is a spring that flows into a small lake. The island was originally inhabited by the Wampanoag Indians. There is a legend that a young Wampanoag man, the son of a chief, settled on the shore of the small lake. His name, also the name of the lake and the spring, was Tashmoo. Early records of the area refer to the spring and lake as Kuttastummoo, meaning "place of the great spring." The name was variously spelled as Ketesshame, Catashimoo, and, later, Tashmoo. Did Pridgeon know of this legend and this lake? Did he suggest this name to the White Star Line board of directors when they named their new park? We do not know for certain, but it does seem most probable.

Yet, whatever the meaning of the word *Tashmoo* or how it came to be, both the park and the steamer have a very special place in the history of Harsens Island, the Flats, and the Detroit River region.

One

THE EARLY YEARS

Steamer service from Detroit to Port Huron began in 1829 with the *Argo*, a very primitive vessel with a four-horsepower steam engine. Traveling past the Flats and Harsens Island and on up the St. Clair River, it took the *Argo* two days to reach Port Huron. Other steamboats followed the *Argo*, but it was not until the 1870s and 1880s—with the growth of clubs, resorts, and hotels—that there was anything approaching regular service to Harsens Island and the Flats. Prior to the establishment of the White Star Line and the launching of the steamer *Tashmoo*, service to the Flats was provided by a number of different companies. One of these, a forerunner of the White Star Line, was a company called the Star Line of Steamers, which began service in the spring of 1874. Several other companies continued to provide service, but by the early 1890s, principal among these were the steamers of the Star-Cole and Red Star Lines, a group of companies under the control of Capt. Darius Cole. The Star-Cole Line was made up of a fleet of steamers that included the *Greyhound*, the *Darius Cole*, the *Idlewild*, and in 1896, the new *City of Toledo*. By the late 1890s, visitors to the Flats became too numerous for the hotels and resorts. The steamer companies began to promote picnic grounds for their excursion passengers and to charter parties of church, fraternity, and factory groups. Change was underway. The early years of steamer service to the Flats and Harsens Island were coming to an end.

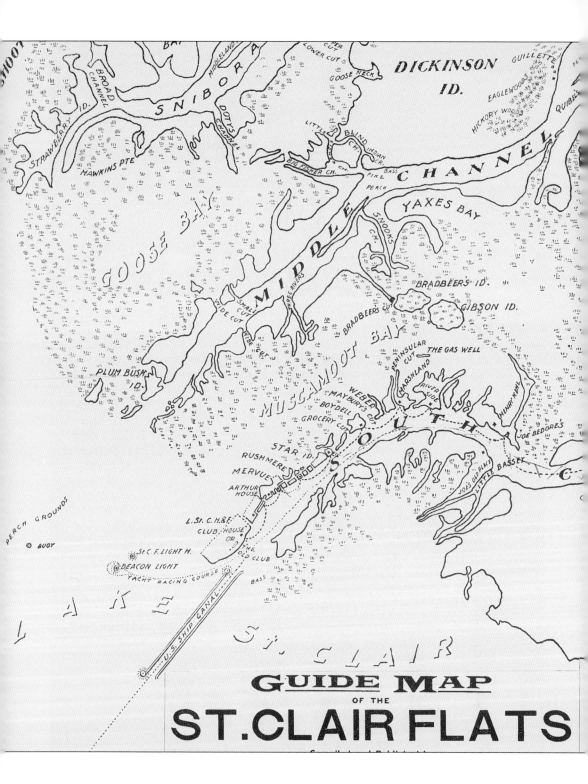

GUIDE MAP
OF THE
ST.CLAIR FLATS

10

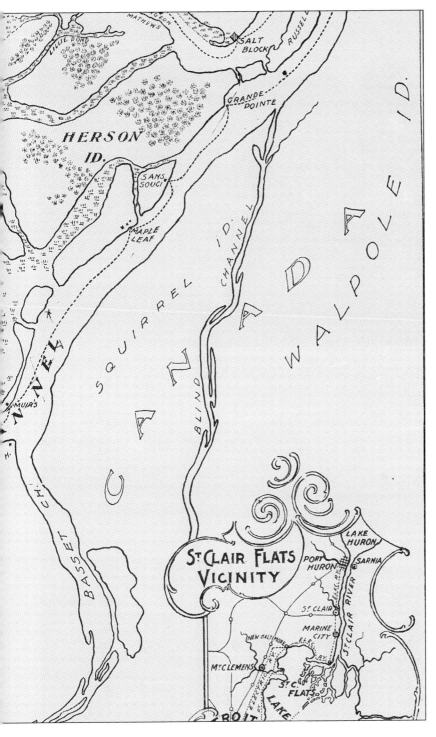

GUIDE MAP, 1895. This detailed map, published in 1895, shows the stops of the Star-Cole Line steamers at the clubs and hotels of the Flats and Harsens Island (note the interesting misspelling of "Herson" Island). In the lower left is the US Ship Canal, opened in 1871. Note the symbols for the lighthouses at each end of the canal's northern bank. Just to the left of the canal are the South Channel Range Lights, which began operation in 1859 and marked the old shipping entrance to the South Channel. The future Tashmoo Park would soon be opened on Harsens Island between the stops at Maple Leaf and Sans Souci. (Courtesy of Michael Dixon.)

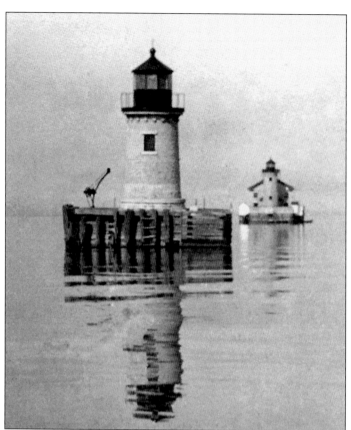

RANGE LIGHTS, 1898. To help guide ships through the very difficult entrance to the South Channel, these two range lights were built in 1859. The rear light, located approximately 1,000 feet northeast of the front light, also included a two-story brick keeper's building. The lighthouse keeper and his family lived here during the shipping season before winter ice closed the channel. (Courtesy of Save Our South Channel Lights.)

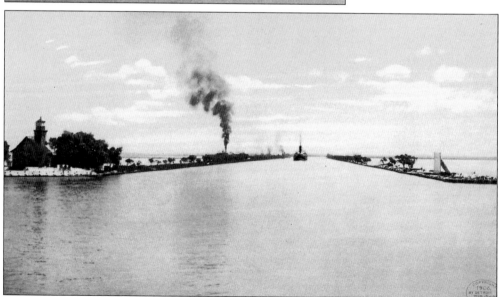

US SHIP CANAL. This straight-path government channel, seen from the bow of a vessel entering the US Ship Canal, opened in 1871. The canal was a mile shorter and a far safer passage than the natural crooked channel it replaced. To mark the entrances, a lighthouse was built at each end of the north bank. (Courtesy of SMM Collection.)

Capt. Darius Cole. Running his fleet of boats from Detroit downriver to Toledo and upriver to Port Huron, Capt. Darius Cole was one of the early developers of steamboat service on the Detroit and St. Clair Rivers. In 1887, along with Charles F. Bielman, he purchased a controlling interest in the Star Line and formed the Star-Cole Line, a forerunner of the White Star Line. (Courtesy of Dossin Great Lakes Museum.)

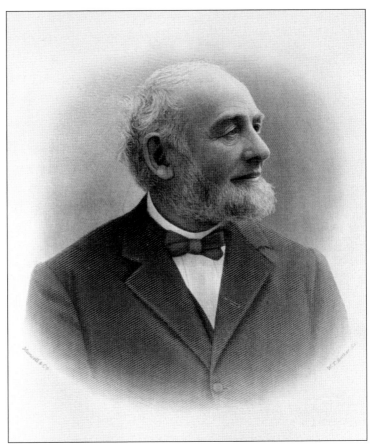

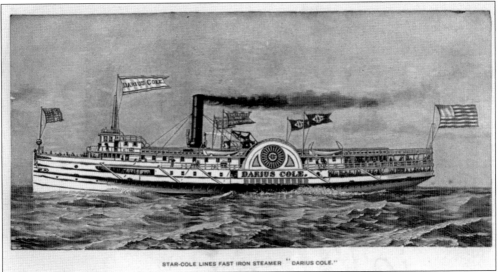

Steamer Darius Cole. The 215-foot *Darius Cole* was an iron-hulled vessel built in Cleveland in 1885. She would serve the Detroit-to-Port Huron run until the turn of the century, when she was replaced by newer and larger vessels. It is said that the steamer was named for the owner's nephew, who just happened to have the same name as his uncle. (Courtesy of SMM Collection.)

GREYHOUND AND DARIUS COLE

RUNNING BETWEEN

DETROIT AND PORT HURON.

TWO TRIPS DAILY.

SUMMER TIME TABLE.

GOING NORTH—READ DOWN.		MILES.	DETROIT CITY TIME.	GOING SOUTH—READ UP.	
‡ 9.00 A. M.	‡ 3.30 P. M.	0	Lv.............Detroit¹...........Arr.	12.00 NOON.	9.00 P. M.
....		" †.........Club Houses........... "
11.20 "	5.50 "	28	" †..........Star Island..... "	9.30 A. M.	7.10 "
11.35 "	6.05 "	31	" †..........Jo. Bedore's.......... "	9.20 "	7.00 "
11.50 "	6.20 "	36	" †...... .. Maple Leaf.......... "	9.05 "	6.40 "
12.00 NOON.	6.30 "	38	" †Grande Pointe......... "	9.00 "	6.30 "
12.10 "	6.45 "	40	"Algonac..... ... "	8.45 "	6.10 "
12.30 "	7.05 "	44	" †.......Robert's Landing......... "	8.30 "	5.50 "
12.50 "	7.25 "	48	"Marine City.......... "	8.15 "	5.30 "
1.25 P. M.	8.05 "	55	" †Oakland House... "	7.40 "	5.00 "
1.30 "	8 15 "	56	"St. Clair............ "	7.35 "	4.55 "
2.30 "	9.15 "	67	"Sarnia³............ "	7.10 "
2.40 "	9.30 "	68	Arr..........Port Huron⁴.........Lv.	7.00 A. M.	4.15 P. M.

† Stops on signals only. ‡ Sunday morning steamer leaves Detroit one-half hour later; afternoon steamer one-half hour earlier.

FAST IRON STEAMER IDLEWILD,

Running between DETROIT and TOLEDO – Daily.

SUMMER TIME TABLE—Detroit City Time.

Leave TOLEDO week days, 8:30 a. m.; Sundays, 9:00 a. m. Arrive DETROIT week days, 1:00 p. m.; Sundays, 2:00 p. m.

RETURNING.—Leave DETROIT week days 4:00 p. m.; Sundays, 5:00 p. m. Arrive TOLEDO⁵ week days, 8:00 p. m.; Sundays, 9:00 p. m.

CONNECTIONS.—¹With D. & C. S. N. Co. and all railroads diverging. ²With Northwest Transportation Co. for Sault Ste. Marie, Duluth, etc., and G. T. R'y for points East. ⁴With F. & P. M. R'y for Port Austin, Bad Axe, etc. ⁵With all railways diverging.

WHARVES—Foot of Griswold St., Detroit. Foot of Jefferson St., Toledo.

D. COLE, General Manager Star-Cole Lines. J. W. MILLEN, General Manager Red Star Line.

C. F. BIELMAN, Treasurer and Traffic Manager.

DETROIT, MICH.

2'

STEAMER SCHEDULE, 1892. Here is the summer time table for the Star-Cole Line steamers *Greyhound*, *Darius Cole*, and *Idlewild* for 1892. An advertisement stated that a trip aboard these steamers "comprises a ride up the Detroit River, across Lake St. Clair and the far famed St. Clair Flats Fishing and Shooting Grounds, stopping at and affording an excellent view of the numerous Club Houses and Summer Resorts, traversing the entire length of the river St. Clair to Port Huron, by daylight." This "delightful round trip, from Detroit, will cost you, including fare, dinner and supper, only $2.00." It was also suggested that "should your time be too limited to take the round trip to Port Huron, you can leave Detroit at 3:30 p.m. for Star Island, and get a fish supper, and return, arriving at Detroit at 9:00 p.m. Fare for this round trip, including supper, $1.00." (Courtesy of Jean Nelson.)

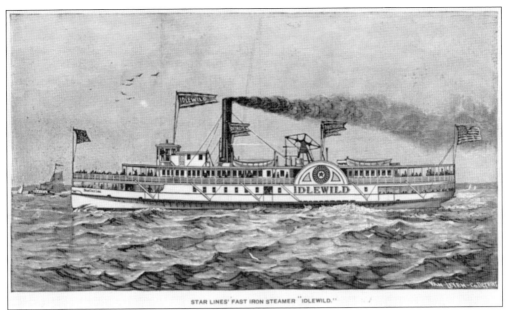

STEAMER IDLEWILD. This iron-hulled steamer was launched in 1879 as the *Grace McMillan* and renamed *Idlewild* in 1881. She was owned by several companies, served a variety of routes from Toledo to Detroit and St. Clair River until finally being converted to a barge in 1914, and was then scrapped in 1923. (Courtesy of SMM Collection.)

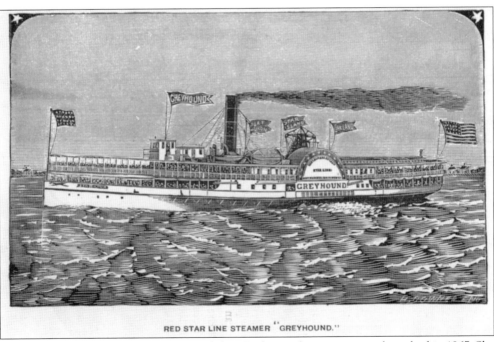

STEAMER GREYHOUND. Originally named the *Northwest*, this steamer was launched in 1867. She was completely rebuilt and renamed *Greyhound* in 1886 before serving the Cole-Star Lines on the Detroit-to-Port Huron run. She was rebuilt again in 1899 and served the White Star Line until replaced by a new vessel of the same name in 1902. (Courtesy of SMM Collection.)

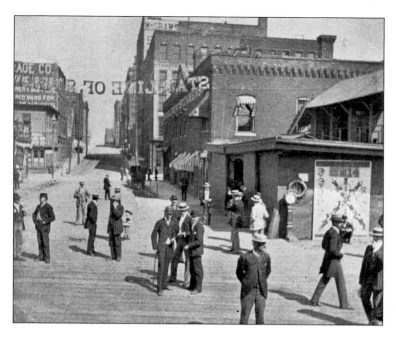

STAR LINE DOCK, 1894. This is a view of the "Star Line of Steamers" (note sign over the street) dock at the foot of Griswold Street on Detroit's waterfront in 1894. The passengers in this view seem to be all men, with the exception of the little girl in the center. Bowlers, straw hats, and walking sticks are very much in evidence. (Courtesy of author's collection.)

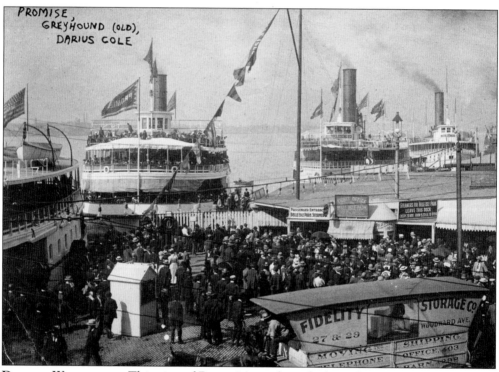

DETROIT WATERFRONT. This view of Detroit's waterfront, looking downriver from Woodward Avenue, dates from 1895. Seen in the far left is the stern of the ferry *Pleasure*, and astern of her is her fleet-mate *Promise* at the dock, loading passengers for Belle Isle. The steamer *Greyhound* is behind *Promise* and will soon be on her way to the Flats and Port Huron. At far right is the *Darius Cole*, boarding passengers for the run to Toledo. (Courtesy of William M. Worden.)

16

A FOURTH OF JULY TRIP. This 1896 advertisement from the *Detroit Free Press* features the Star-Cole Line's newly purchased steamer *City of Toledo*. The vessel sailed from Detroit to Port Huron and "way ports," including a stop at the Star Island House at the Flats. The steamer left the Griswold Street Wharf in Detroit at 9:00 a.m. and returned to the city at 8:30 p.m. (Courtesy of author's collection.)

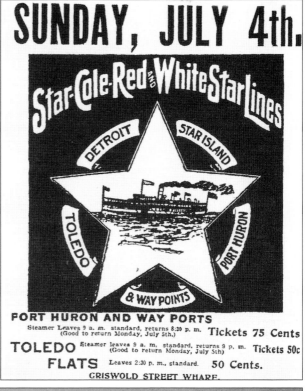

SUNDAY, JULY 4th.

Star-Cole-Red and White Star Lines

DETROIT · STAR ISLAND · TOLEDO · PORT HURON

& WAY POINTS

PORT HURON AND WAY PORTS
Steamer Leaves 9 a. m. standard, returns 8:30 p. m.
(Good to return Monday, July 5th.) **Tickets 75 Cents**

TOLEDO Steamer leaves 9 a. m. standard, returns 9 p. m.
(Good to return Monday, July 5th) **Tickets 50c**

FLATS Leaves 2:30 p. m., standard. **50 Cents.**

GRISWOLD STREET WHARF.

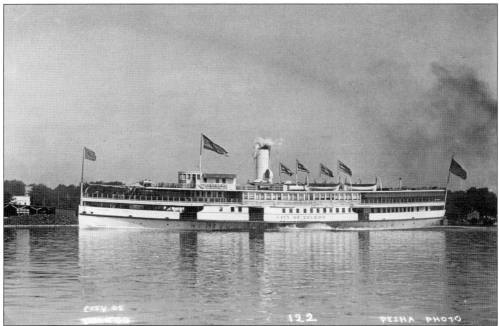

STEAMER CITY OF TOLEDO. This steel-hulled steamer, launched by the Craig Shipbuilding Company in 1891 at its yard in Toledo, soon joined the fleet serving the Toledo-Detroit-Port Huron route. In 1896, she was purchased by the newly organized White Star Line as their first-owned vessel. (Courtesy of SMM Collection.)

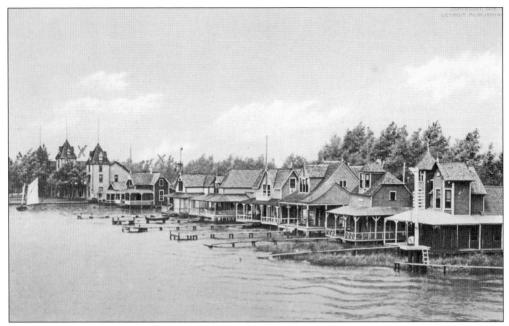

COTTAGES AT THE FLATS. Along with stops at the clubs and hotels, many passengers riding the excursion steamers were traveling to their summer cottages at the Flats, like those pictured here. The distinctive towers of the Riverside Hotel can be seen at the far left of this image. (Courtesy of Gary Grout.)

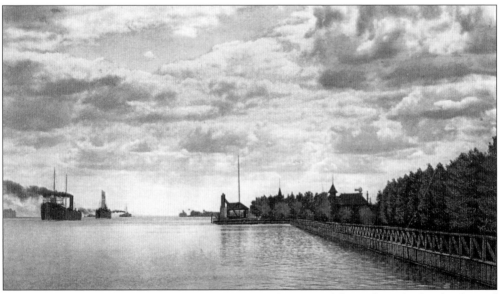

THE FLATS AT NIGHT. At sunset, freighters are seen sailing up and down along the South Channel at the Flats. At the right is the silhouette of the Rushmere Hotel. The excursion steamers have left for Detroit but will be back tomorrow with another full load of vacationers. (Courtesy of Gary Grout.)

Two

DETROIT TO PORT HURON

The steamer *Tashmoo* was launched December 30, 1899, and after her successful shakedown cruise and trial run, she entered service on the White Star Line's Detroit-to-Port Huron run in June 1900. After leaving the White Star Line dock in Detroit at the foot of Griswold Street, she sailed up the Detroit River, across Lake St. Clair, through the US Ship Canal, and arrived at the first of her stops along the Flats and Harsens Island. By the early 1900s, the clubs and hotels at the Flats and Harsens Island were a major destination point for the residents of Detroit. A trip to the Flats aboard the *Tashmoo* for a dinner at one of the hotels, a week's stay at a resort, a month-long visit to a cottage, or a fun-filled outing to Tashmoo Park was just the things to beat the big city's summer heat. In addition, the *Tashmoo* and the other steamers of the White Star Line carried passengers, freight, mail, and newspapers from Detroit to residents of the Flats and Harsens Island and the communities along the St. Clair River. At Port Huron, the *Tashmoo*'s final stop, passengers could make connections to travel by boat up the lakes to northern Michigan or make connections to travel on by train. Using a White Star Line summer-shipping schedule and map, one can follow the steamer *Tashmoo* past the clubs and hotels of the Flats, past Tashmoo Park on Harsens Island, and on up the St. Clair River to Port Huron.

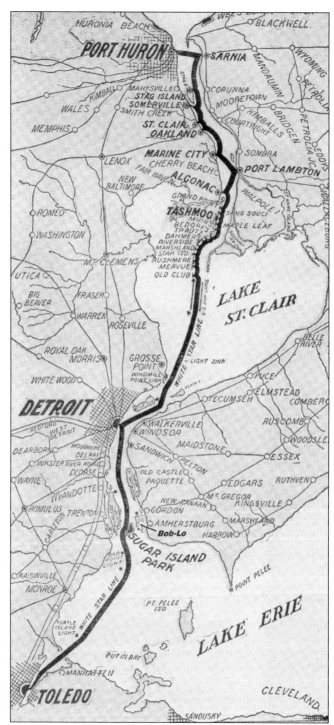

WHITE STAR LINE ROUTE MAP. This map, published in the early 1920s, shows the route of the steamer *Tashmoo* and the other White Star Line boats on their way from Detroit to Port Huron. The map also shows the route to Toledo. Seen here are the stops at the hotels and clubs of the Flats and, of course, the stop at Tashmoo Park. (Courtesy of Michael Dixon.)

SUMMER TIME TABLE

Steamers Run Daily Except as Noted
Subject to Change Without Notice

GOING NORTH, READ DOWN			Mls.	CENTRAL STANDARD TIME		GOING SOUTH, READ UP		
		SUNDAYS					SUNDAYS	
In effect June 15 to Sept. 2	In effect April 20 to Oct. 5	Leave Toledo 9 15 AM 2 30 PM Arrive Sugar Is.		TOLEDO AND DETROIT		In effect April 20 to Oct. 5	Arrive Toledo 1 00 PM 9 00 " Arrive Sugar Is.	In effect June 15 to Sept. 2
2 30 PM	°8 30 AM	12 00 M		Lv TOLEDO, OHIO Ar		8 30 PM	9 45 AM	1 00 PM
5 30 "	11 30 "	5 30 PM		Ar ... SUGAR ISLAND PARK Lv		5 50 "	6 30 PM	
5 55 "	11 35 "	Arrive	42	Lv ... SUGAR ISLAND PARK ... Ar		5 45 "	Leave	9 45 AM
7 15 "	1 00 PM	Detroit 1 45 PM 7 15 "	60	Ar DETROIT, MICH. Lv	‡4 30 "		Detroit 8 30 AM 5 00 PM	8 30 "

In effect June 15 to Sept. 22	In effect April 13 to Oct. 1	In effect June 18 to Sept. 1		DETROIT AND PORT HURON		In effect June 18 to Sept. 1	In effect April 13 to Oct. 1	In effect June 15 to Sept. 22
§8 45 am	2 30 pm	† 4 00 pm		Lv DETROIT, MICH. Ar		‡8 40 am	11 30 am	8 50 pm
10 35 "	4 20 "	+ 6 00 "	 *Old Club		‡6 50 "	9 45 "	7 10 "
10 41 "	4 26 "	+ 6 05 "	 *Hotel Muscamoot		‡6 45 "	7 05 "
10 45 "	4 30 "	+ 6 10 "	 *Rushmere		‡6 43 "	9 40 "	7 02 "
10 50 "	4 35 "	+ 6 15 "	 *STAR ISLAND		‡6 40 "	9 35 "	7 00 "
10 56 "	4 40 "	+ 6 20 "	 *Marshland		‡6 35 "	9 30 "	6 50 "
11 00 "	4 45 "	+ 6 25 "	 *Riverside		‡6 30 "	9 28 "	6 45 "
11 05 "	4 50 "	+ 6 30 "	 *Forsters		‡6 25 "	6 40 "
11 10 "	5 00 "	+ 6 40 "	 *Bedores		‡6 20 "	9 25 "	6 37 "
11 20 "	5 10 "	+ 7 00 "	 *Muirs		‡6 10 "	9 20 "	6 30 "
11 35 "	5 20 "	+ 7 15 "		... *TASHMOO PARK LANDING ...		‡6 00 "	9 15 "	6 20 "
11 45 "	5 30 "	+ 7 25 "	 *Grande Pointe		‡5 45 "	9 05 "	5 48 "
12 00 m	5 45 "	+ 7 50 "	 ALGONAC		‡5 30 "	8 50 "	5 34 "
12 15 pm	6 00 "	+ 8 10 "		... *PORT LAMBTON, ONT. ...		‡5 15 "	8 35 "	5 15 "
12 35 "	6 20 "	+ 8 40 "	 MARINE CITY		‡5 00 "	8 20 "	4 58 "
1 10 "	7 05 "	+ 9 30 "	 ST. CLAIR			7 55 "	4 28 "
1 33 "	7 35 "		 *Stag Island			7 30 "	4 09 "
1 51 "	8 00 "	+10 15 "	 *South Park			7 15 "	3 54 "
2 10 "	8 05 "	+10 20 "	 SARNIA, ONT.		‡......	7 05 "	3 39 "
2 15 "	8 15 "	+10 30 "		Ar ... PORT HURON, MICH. Lv		11 00 pm	‡7 00 "	3 30 "

*Flag Stations—Steamers stop on signal when time is given only
+Daily except Sundays
°Sundays, leave 9.15 a. m.
§Sunday morning steamers leave 9.00
‡Sundays, leave one-half hour later

Connections are made at TOLEDO with railroads diverging. At DETROIT with D. & C. magnificent steamers for Cleveland and Buffalo and all railroads. At SARNIA, Ont., with Northern Navigation Co. Steamers for Sault Ste. Marie, Port Arthur and Duluth and Grand Trunk Railway for all points in Canada. At PT. HURON with Pt. Huron and Duluth Steamers for Duluth.

Steamers Leave Foot of

Adams Street	Butler Street	Griswold Street
Toledo, Ohio	**Port Huron, Mich.**	**Detroit, Mich.**

B. W. PARKER, President and General Manager Detroit
JOHN PRIDGEON, Vice-President Detroit
C. F. BIELMAN, Traffic Manager Detroit
GEO. E. PHILLIPS, Treasurer and Assistant Traffic Manager . . Detroit
L. H. ...ER, T. P. A. and Exn. Agent Detroit
C. LEIDICH, Ticket Agent 174 Griswold St., Detroit
A. N. KNAPP, Agent Toledo
H. E. STALKER, D. P. A. Toledo
GEO. H. COURSE, Agent Port Huron
NORTHERN NAV. CO., Agents Sarnia, Ont.
F. B. CLARKE, Agent London, Ont.

SUMMER TIME TABLE. This White Star Line summer timetable was issued along with the map on the facing page. At the height of the summer season, the steamer *Tashmoo* left the dock at Detroit promptly at 8:45 a.m. and arrived at Tashmoo Park at 11:35 a.m. sharp. After a fun-filled day at the park, visitors boarded the *Tashmoo* at 6:20 p.m. and arrived back in the city at 8:50 p.m. (Courtesy of Michael Dixon.)

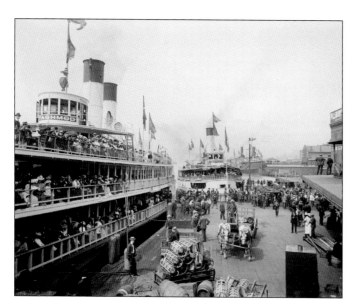

TASHMOO LOADING PASSENGERS. Here, last-minute passengers hurry to board the *Tashmoo* as she prepares to leave for her scheduled trip to Port Huron in 1901. Freight and supplies have already been sent aboard. Note the nearly empty teamster's wagon in the center foreground. The ship is only moments away from departure. Astern of the *Tashmoo* is the *Idlewild*, loading passengers for her trip to Toledo. (Courtesy of Detroit Publishing Company, Library of Congress.)

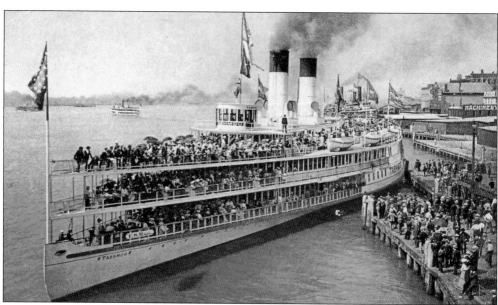

TASHMOO GETS UNDERWAY. Her whistle has sounded, and the *Tashmoo* pulls away from the White Star Line dock at the foot of Griswold Street on Detroit's busy waterfront. Note Capt. Burton S. Baker, who served as master on the *Tashmoo* from 1900 until 1922, on the port side bridge of the pilothouse. It appears that the steamer is loaded to capacity with passengers looking forward to a pleasant day's outing to the Flats, Tashmoo Park, and points north. (Courtesy of Gary Grout.)

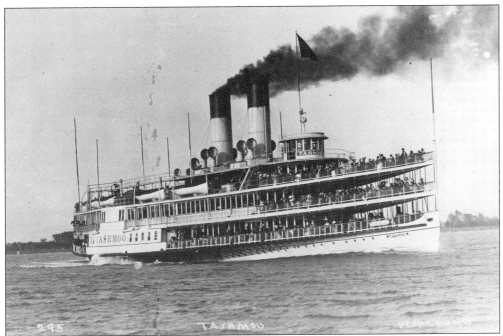

TASHMOO HEADS NORTH. Sailing up the Detroit River and across Lake St. Clair, the *Tashmoo* will soon reach the entrance to the US Ship Canal. She appears to be traveling at full speed. Note the churning paddle wheel below the ship's name on her starboard paddle wheel box. (Courtesy of Erik Hall.)

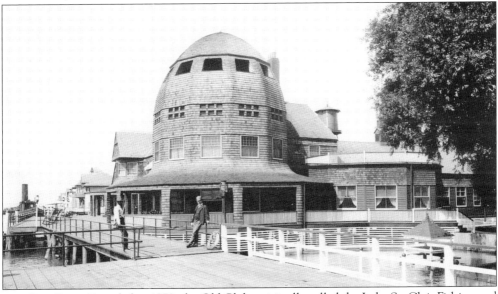

THE OLD CLUB. Founded in 1872, the Old Club, originally called the Lake St. Clair Fishing and Shooting Club, was the steamer *Tashmoo's* first stop upon entering the South Channel. The club was organized by a group of prominent Detroit sportsmen who knew of the Flats as one of the region's finest duck-hunting and fishing grounds. The clubhouse pictured here was built in 1887 to accommodate an expanding membership. This third clubhouse was designed by architect Walter MacFarlane. (Courtesy of Detroit Publishing Company, Library of Congress.)

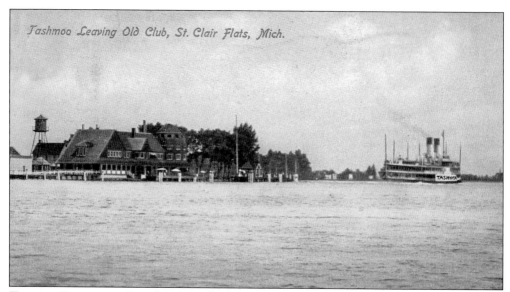

Tashmoo Leaving Old Club, St. Clair Flats, Mich.

TASHMOO LEAVES THE OLD CLUB. By the late 1890s, membership was changing from a hunting and fishing club to a social and boating club. As a result, the club was reorganized in 1902 and renamed the Old Club. In this view, the steamer *Tashmoo* is seen leaving the Old Club on her way up the channel to Tashmoo Park. On April 19, 1926, fire destroyed this clubhouse. Shortly thereafter, a new clubhouse was built and still stands to this day. (Courtesy of Gary Grout.)

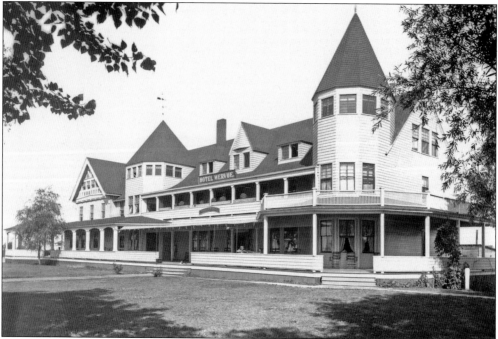

THE HOTEL MERVUE. Opened in 1899 as a private club, the hotel was renamed the Mervue and opened to the public in 1901. Over the years, this hotel was known by many names: New Mervue Club, the Muscamoo Hotel, the New Club, the Hotel Gornran, and finally, the Miller Hotel. Torn down in the 1940s, it was considered one of the most unique summer resorts in the world during its heyday. (Courtesy of Detroit Publishing Company, Library of Congress.)

THE RUSHMERE HOTEL. The largest clubhouse ever built at the Flats was the Rushmere. Constructed in 1884 for the Detroit Fishing and Hunting Association, it could accommodate 150 guests. Sadly, on August 29, 1908, while guests were enjoying a luncheon picnic and lawn games, a kitchen grease fire burned down this beautiful building. (Courtesy of Detroit Publishing Company, Library of Congress.)

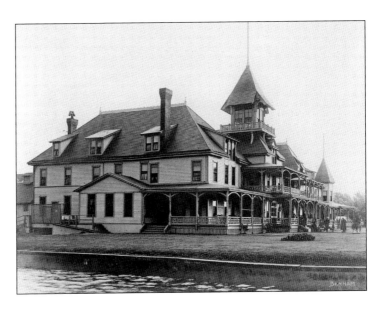

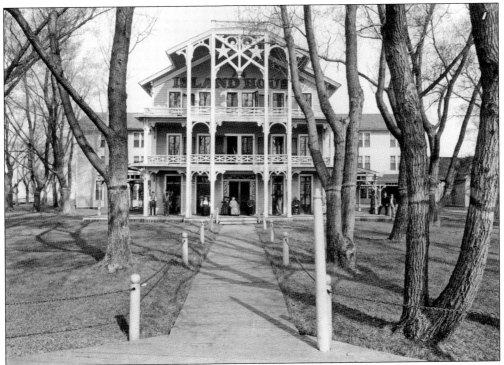

STAR ISLAND HOUSE. The Star Island House introduced the middle class to the St. Clair Flats. In 1875, a three-story hotel with 26 rooms was constructed by the Star Line, forerunner of the White Star Line. The building was expanded, and by 1895, it contained over 100 rooms and boasted a fine dining room with a seating capacity of 500, the largest in the state of Michigan at the time. (Courtesy of Detroit Publishing Company, Library of Congress.)

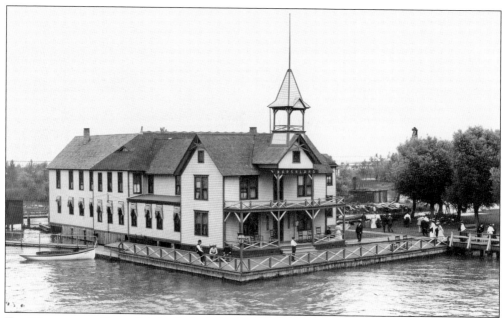

THE MARSHLAND CLUB. Originally built for the Peninsular Fishing and Shooting Club in 1885, this hotel was renamed the Marshland Club and opened to the public in 1895. The club could accommodate 75 guests and included a dining room and dancing area. The grounds also included the Red House, a bar behind the hotel where guests spent many happy afternoons drinking and playing cards on the porch. (Courtesy of Detroit Publishing Company, Library of Congress.)

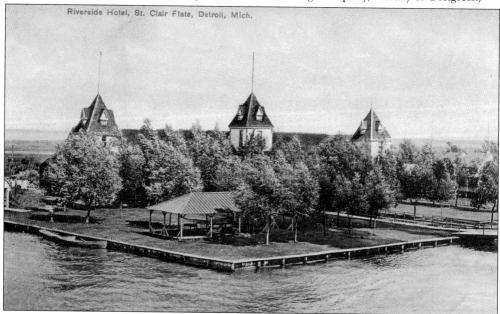

THE RIVERSIDE HOTEL. The Riverside Hotel first opened in 1891. The building's distinctive towers and large balcony were added about 1893. Christened the Idle Hour in 1917, it was destroyed by fire but rebuilt in 1934. It was later sold and renamed Club Aloha. It closed in the 1970s but was reopened in the 1980s. Today, it remains open as the Idle Hour Boat Club and appears much as it does in this early view. (Courtesy of Gary Grout.)

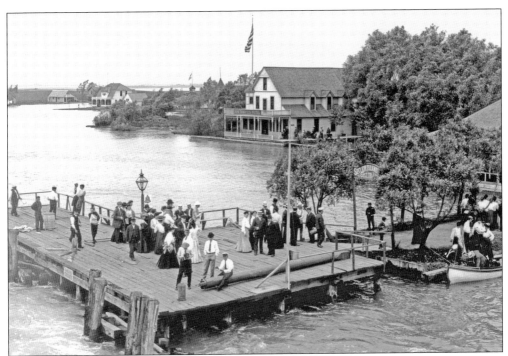

THE DOCK AT TRAUTZ'S HOTEL. Built in the 1870s, this hotel was purchased by Gus Trautz in 1898. It was known by many names: Kehl's Public House, St. Clair Island House at Willow Grove, Trautz's, Forester's, Kulow's, Seaway, 4-B's, and Jacob Harsens Harbor Club. Today, the beautifully restored hotel is part of the South Channel Yacht Club and is one of the last remaining landmarks from the *Tashmoo* era. (Courtesy of Detroit Publishing Company, Library of Congress.)

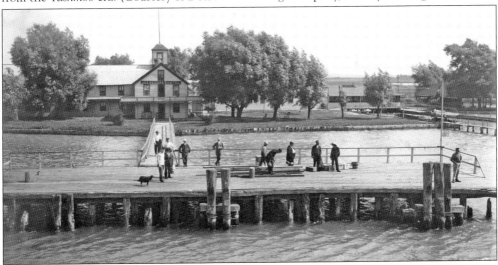

JOE BEDORE'S HOTEL. Joe Bedore, a French Canadian known as the "King of the Flats," was remembered for his great humor and storytelling. Bedore's hotel became the most famous of all the waterside roadhouses. Joe and his wife, Marceline, ran the hotel together for over 30 years. They both died in 1921, but the hotel continued on successfully through the 1940s. It struggled through the 1950s, and closed for good in 1960. In 1968, the building was torn down. (Courtesy of Detroit Publishing Company, Library of Congress.)

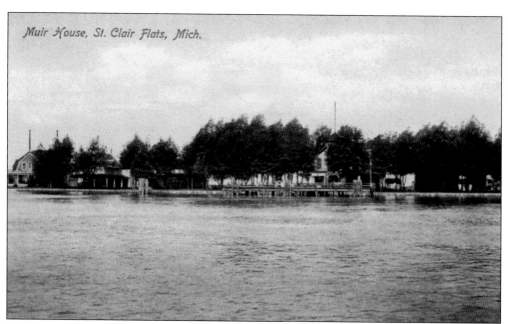

Muir House, St. Clair Flats, Mich.

THE MUIR HOUSE. This hotel was opened by the Muir family in 1890. The Muir House had no bar and was known as the hotel where single women could feel at home. In 1916, Walter Lemke purchased the building and moved it on a scow to adjoin his hotel near San Souci, just a short walk from Tashmoo Park. (Courtesy of Gary Grout.)

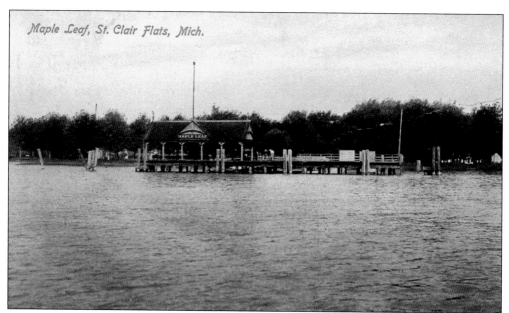

Maple Leaf, St. Clair Flats, Mich.

THE DOCK AT MAPLE LEAF. The Maple Leaf stop for the White Star Line steamers was not the site of a hotel but the location of a group of beautiful Victorian summer homes. Many of these original cottages still stand, and the historic character of these homes is a fine reminder of the elegance of the Victorian era on Harsens Island and the Flats. The dock was torn down in the 1930s. (Courtesy of Gary Grout.)

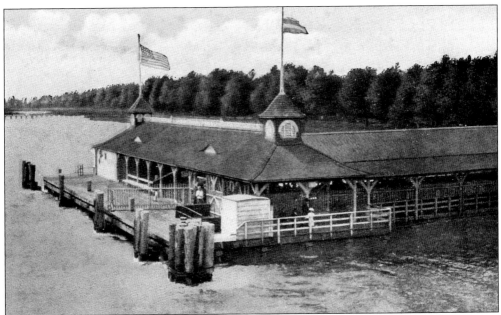

THE DOCK AT TASHMOO PARK. The next stop for the White Star Line was the dock at Tashmoo Park. The park, owned by the White Star Line, was the reason the steamer *Tashmoo* was built—to carry visitors from Detroit to this beautiful island locale. The park's last season was 1951, and this dock sat unused and deteriorated. In 1955, it finally collapsed into the river and was removed. (Courtesy of Gary Grout.)

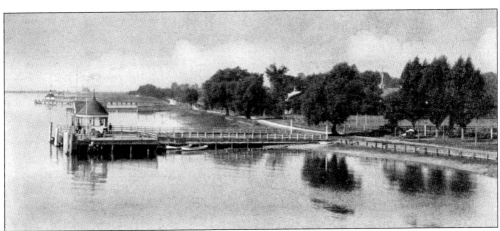

SANS SOUCI LANDING. Sans Souci (meaning "without care") was first plotted in 1890 and eventually became the commercial district for Harsens Island. It was here, in about 1895, that William LeCroix built this dock, pavilion, and freight shed. In 1898, he constructed a general store across the road from the dock. When the steamers stopped using the landing at Sans Souci, the pavilion found new uses. The original dock property was filled in, and the enclosed and enlarged pavilion today houses a popular tavern. (Courtesy of Library of Michigan.)

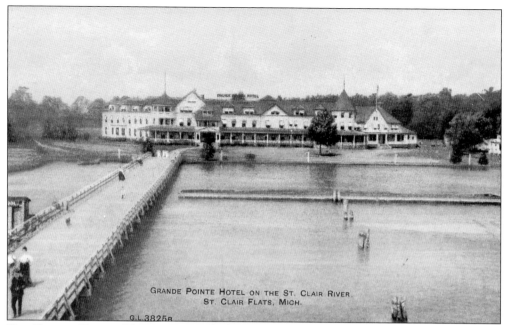

GRANDE POINTE HOTEL ON THE ST. CLAIR RIVER
ST. CLAIR FLATS, MICH.

G.L.3825R

THE GRANDE POINTE HOTEL, 1909. The last stop on Harsens Island for the *Tashmoo* was the Grande Pointe Hotel. Opened in 1890, the Grande Pointe, which featured 150 rooms, was one of the finest resorts on the Great Lakes. Sadly, this beautiful hotel was destroyed by fire in 1909 and never rebuilt. Although the hotel was gone, it continued to be a stop for the *Tashmoo* due to the presence of the many fine homes built here—one of these being the summer house of A.A. Parker, president of the White Star Line. (Courtesy of Gary Grout.)

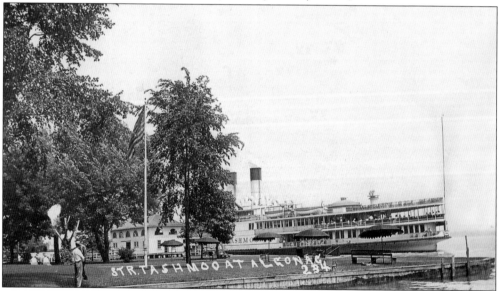

STEAMER TASHMOO AT ALGONAC. Founded in 1867, the town of Algonac was the *Tashmoo's* first mainland stop after leaving Harsens Island. Several of the island's hotels, particularly the Grande Pointe, maintained regular service by motor launch to Algonac for their visitors. Algonac, a popular vacation community, was also a center of the pleasure-boat industry and home of the famous Chris-Craft Company. (Courtesy of Erik Hall.)

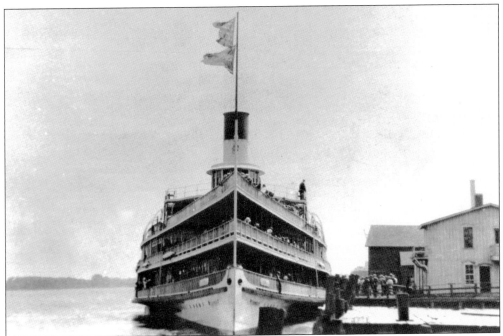

At the Union Street Dock. Only minutes up the St. Clair River from Algonac was Marine City, where the *Tashmoo* stopped at the Union Street dock. Located where the Belle River flows into the St. Clair River, Marine City was a major shipbuilding center. During the later part of the 19th century and the early 20th century, over 250 wooden boats were built here in the city's several shipyards. The city was also home to many of the lake's professional sailors. (Courtesy of Erik Hall.)

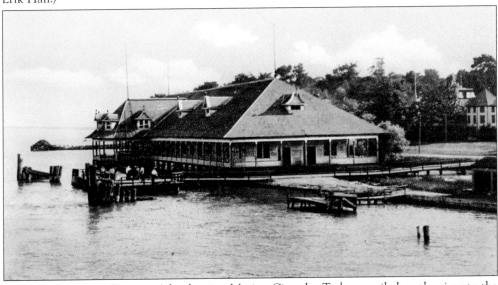

The Dock at Stag Island. After leaving Marine City, the *Tashmoo* sailed up the river to the town of St. Clair and then stopped at Stag Island. Located on the Canadian side of the river, Stag Island was a popular summer resort. By 1905, accommodations included a fine hotel with an elegant dining room and 21 guest cottages. In addition to the White Star Line, the steamer *Hiawatha* made six trips daily to the island from Sarnia, Ontario. (Courtesy of Gary Grout.)

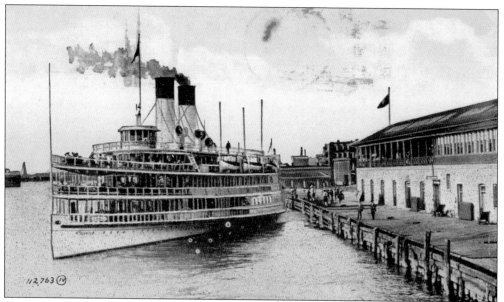

THE TASHMOO LEAVING SARNIA. The *Tashmoo's* next-to-last stop was the Canadian city of Sarnia, located at the mouth of the St. Clair River across from Port Huron. Here, passengers were able to make connections with steamers of the Northern Navigation Company for the cities of Sault Ste. Marie, Port Arthur, and Duluth. Also, passengers were able to make connections here for rail passage to the east via the Grand Trunk Railroad. (Courtesy of Gary Grout.)

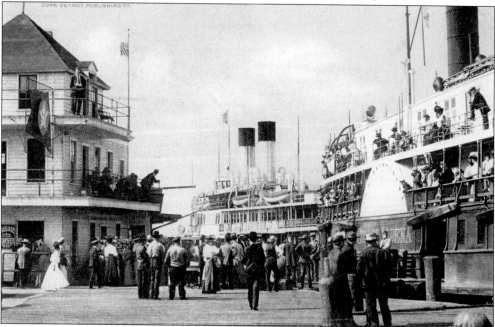

GETTING READY TO HEAD NORTH. Port Huron was the final stop for the White Star Line steamers in their runs from Detroit. In this image dated 1908, the steamer *City of Alpena* of the Detroit and Cleveland Navigation Company is docked just astern of the *Tashmoo* and is making preparations to get underway to points north. Soon, the *Tashmoo* will begin her return trip down to Harsens Island, Tashmoo Park, the Flats, and on to Detroit. (Courtesy of Gary Grout.)

Three

THE PARK

During the 1880s and early 1890s, the various shipping lines that provided day passenger service from Detroit up to Port Huron and downriver to Toledo expanded their services to include trips to picnic grounds. These became an immediate success, and the shipping companies began to develop yet another destination point—amusement parks. To compete with this new type of service, the owners of the White Star Line began plans to develop an amusement park of their own. The company knew of a picnic grove not far from the Flats and thought that this might be a good location. Thus, in 1897, the White Star Line bought 60 acres of land just below Sans Souci on Harsens Island and began to build its amusement park. The company started by investing a few thousand dollars in improvements that included a pavilion, picnic grounds, a couple of baseball diamonds, and a bicycle track. Soon, these would be followed by a dance pavilion, slides and swings, and at the river's edge, a bathhouse and a beach for swimming. In June 1897, the steamer *Greyhound* brought the first excursionists to the new park. Private parties began to reserve the park on the weekdays, and groups from as far away as Ohio came to visit. The park quickly became successful, and the company began plans to have a new excursion day boat built to bring passengers to the park. It would name the new vessel after the park—*Tashmoo*.

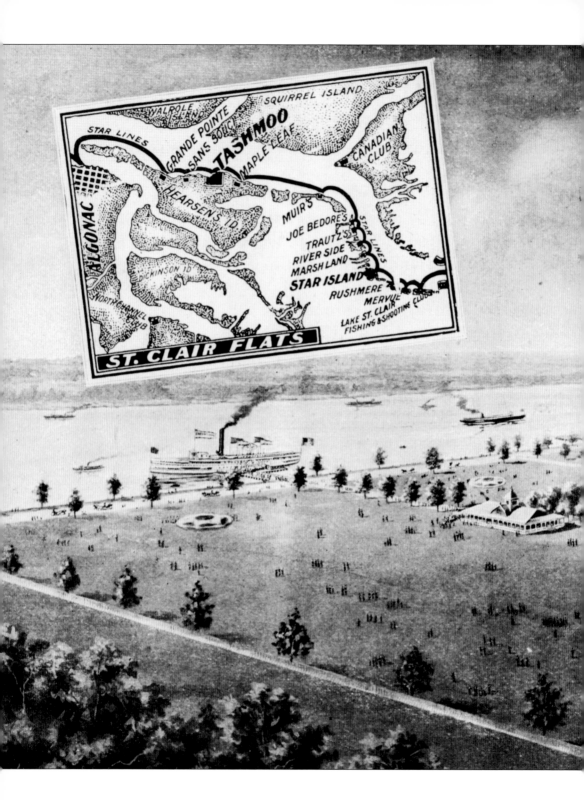

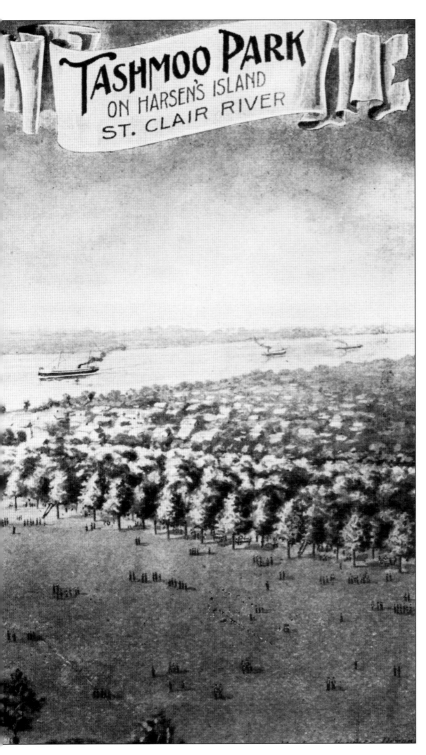

BIRD'S-EYE VIEW.
This engraving from 1899 shows the beautiful grounds of the new park. Its large, covered casino pavilion welcomed guests, and the oak, maple, and willow picnicking grove was liberally supplied with tables, swings, and slides for children. Two baseball diamonds and a bicycle path completed the amenities for this 60-acre park. Note this interesting misspelling of "Hearsen's" Island. (Courtesy of Bob and Susan Bryson.)

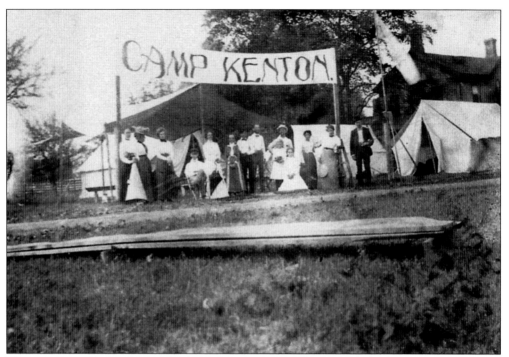

VISITORS FROM OHIO. One of the first groups to visit Tashmoo Park the first year the park was open came all the way from Kenton, Ohio. The group had such a grand time, several more groups came back from Kenton, Bellefontaine, and Findlay, Ohio, during July and August 1898, when these photographs were taken. (Courtesy of Jean Doddenhoff.)

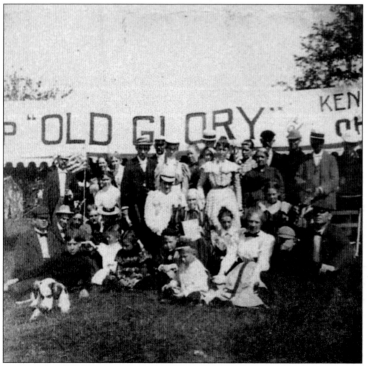

CAMP OLD GLORY. The campers stayed in tents at Tashmoo Park and named their camp Old Glory. They enjoyed swimming, fishing, rowing, sailing, and day trips. In the evening, they enjoyed skits, dance parties, and musical shows. (Courtesy of Jean Doddenhoff.)

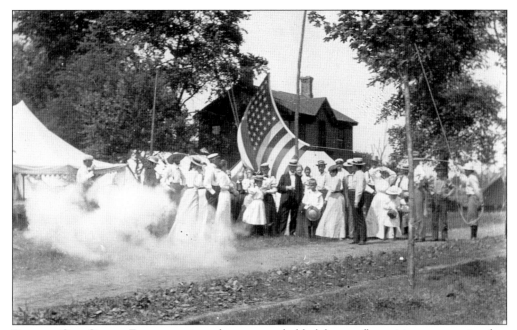

RAISING OLD GLORY. Every morning, the campers held elaborate flag-raising ceremonies that included the firing of a small signal cannon. The campers traveled by train from Kenton to Toledo, then took a steamer to Detroit where they boarded either the *Idlewild* or the *Greyhound* for Tashmoo Park. (Courtesy of Jean Doddenhoff.)

A GOOD TIME HAD BY ALL. The groups, which stayed one to two weeks, sometimes had up to 65 campers in attendance. The campers thoroughly enjoyed themselves, and the Kenton newspaper reported that groups were already planning trips to Tashmoo Park for 1899. (Courtesy of Jean Doddenhoff.)

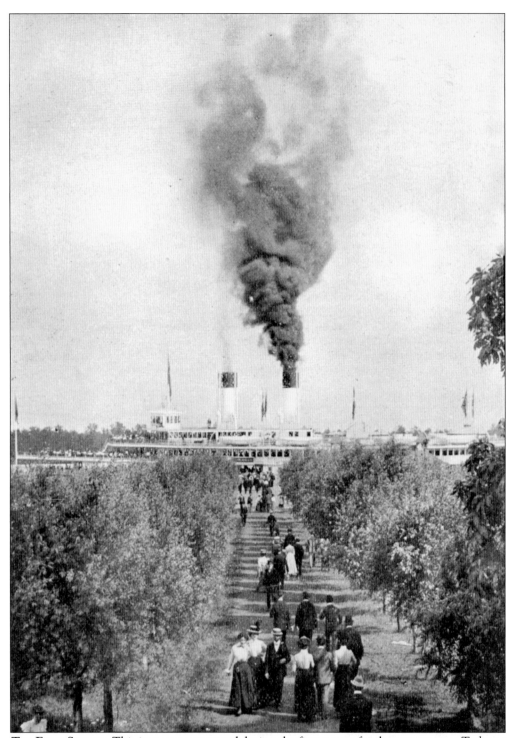

THE FIRST SEASON. This image was captured during the first season for the new steamer *Tashmoo* (the hurricane deck had not yet been extended to the jack staff). Here, she is loading and unloading Parke-Davis Company family members for a day at the park. (Courtesy of Library of Michigan.)

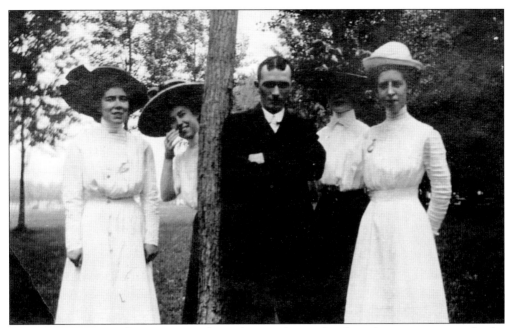

A Day at the Park. Guests visiting the park pause for a rather formal portrait—except for the young lady in the very large hat looking from behind a small tree. This photograph is dated 1910. (Courtesy of Michele Komar.)

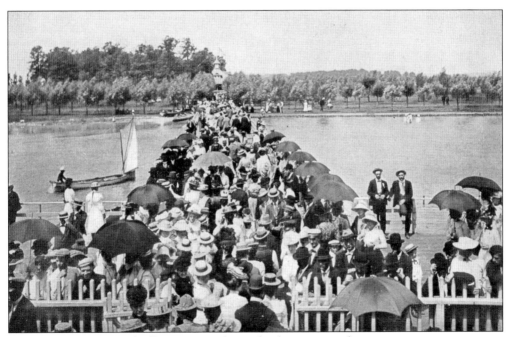

Hot Summer Day. Umbrellas are in evidence this hot summer day as some passengers wait to board the *Tashmoo* while others head to the park. Note the distinctive cupola on the roof of the casino pavilion in the distance. (Courtesy of Library of Michigan.)

OFF TO TASHMOO PARK. These two young ladies are awaiting the departure of the steamer as it prepares to leave the wharf on its way to Tashmoo Park. Others have found chairs on the steamer's forward hurricane deck. (Courtesy of Erik Hall.)

UNDERWAY TO THE PARK. This family is enjoying some shade as the steamer *Tashmoo* heads for the park in this photograph dated 1906. To the left is a mother with two small children ready to enjoy a day at the park. (Courtesy of Erik Hall.)

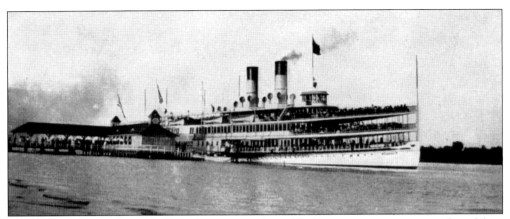

HEADED BACK TO THE CITY. The steamer is just about filled to capacity as passengers board for a ride back to the city. It will not be long now before lines are cut off, the whistle is sounded, and the *Tashmoo* heads down river. (Courtesy of SMM Collection.)

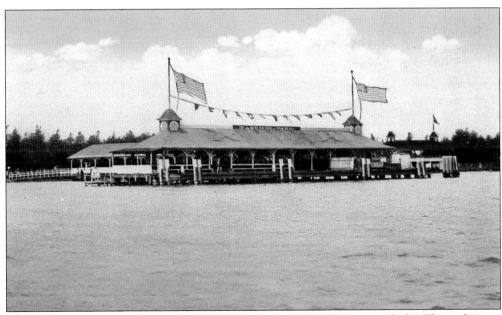

LANDING AT TASHMOO PARK. It will be only moments before the steamer docks. The park's new landing wharf features the shingled cupolas characteristic of all of the park's major buildings. The dock, casino pavilion, and bathhouse all share these interesting architectural details. (Courtesy of Gary Grout.)

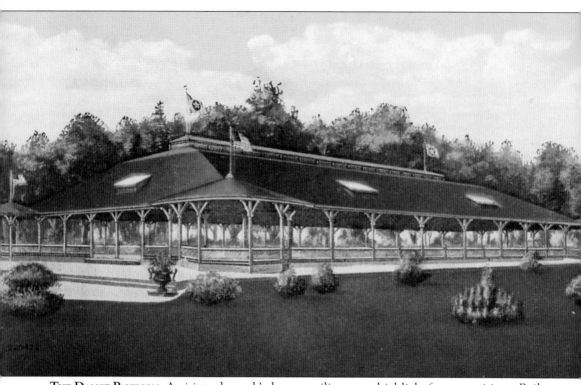

The Dance Pavilion. A visit to the park's dance pavilion was a highlight for many visitors. Built specifically for music and dancing, this structure, which still stands, had a 10,000-square-foot wood floor. (Courtesy of Gary Grout.)

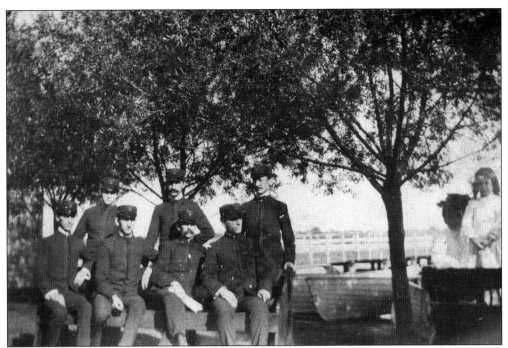

FINZEL'S BAND. William Finzel was a prominent German American Society musician in the Detroit area for nearly half a century. From the beginnings of the White Star Line's incorporation, Finzel would provide musicians for all the line's steamers and park pavilions. In this 1902 photograph, some of the men are resting at the park between sets or waiting for the steamer. (Courtesy of SMM Collection.)

Agreement.

WM. FINZEL, Manager.

Between _White Star Line_ and FINZEL'S ORCHESTRA.

Detroit, Mich., _Mar. 3rd._ 19 04

I hereby agree to pay Wm. Finzel, Manager of Finzel's Orchestra, the sum of $ 141 00/100 for the services of _eight_ men on the following dates, _for week of seven days - Summer Season 1904. on The Str. Tashmoo + Tashmoo Park_

Between the hours of _8 A M_ and _8 30 P M_

If any of the men are not satisfactory to our General Manager

Remarks _they are to be replaced by ones who are._

Signed _White Star Line_

Geo. Parker genl Mgr

Please sign and return this duplicate

MUSIC AT THE PARK. For the then princely sum of $141 a week, Finzel's eight-man band would accompany Detroiters to and from Tashmoo Park and play the most popular music for their guests at the dance pavilion. Ragtime, comedic songs, cakewalks, and shortened pieces of classical music were standard fare. (Courtesy of SMM Collection.)

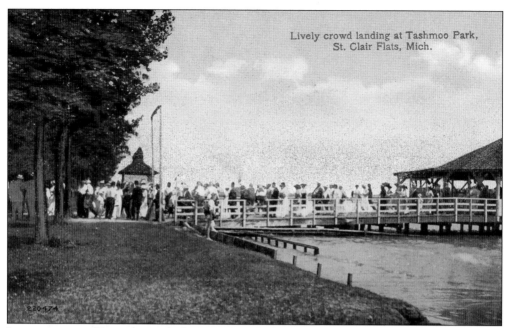

Lively crowd landing at Tashmoo Park, St. Clair Flats, Mich.

LANDING AT THE PARK. A crowd of visitors disembarks from the steamer and heads for a fun-filled day at the park. From the number of people seen here, the steamer must have been occupied to capacity. (Courtesy of Gary Grout.)

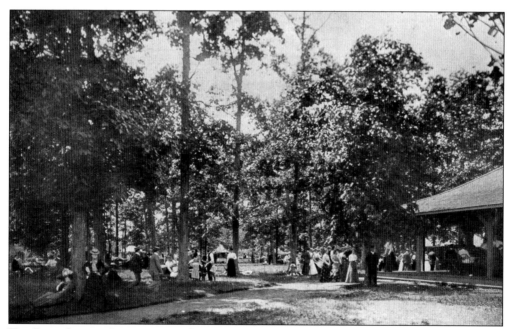

THE PARK GROVE. Guests enjoy a pleasant day in the grove at Tashmoo Park. At the right is the casino pavilion, and souvenir tents can be seen in the background. A visit to shop for souvenirs was always an important part of a day at the park. (Courtesy of Library of Michigan.)

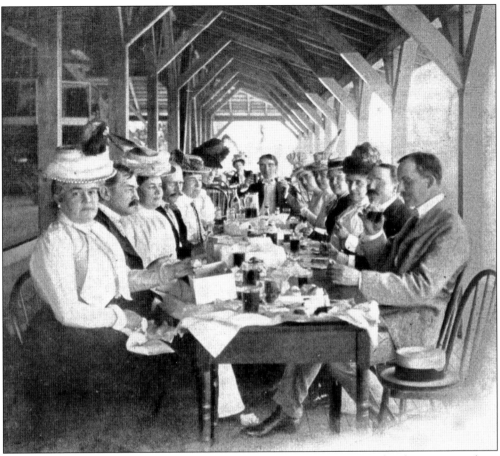

LUNCH AT THE PARK. Visitors enjoy lunch at Tashmoo Park. Food was served at the casino pavilion. As part of a most pleasant way to spend the day, this group appears to be finishing a meal before boarding an afternoon steamer back to Detroit. (Courtesy of Library of Michigan.)

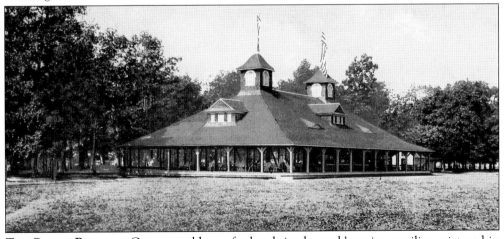

THE CASINO PAVILION. Guests would stop for lunch in the park's casino pavilion, pictured in 1901. This building, which still stands, has the distinctive shingled cupolas found on so many of the park's buildings. (Courtesy of Gary Grout.)

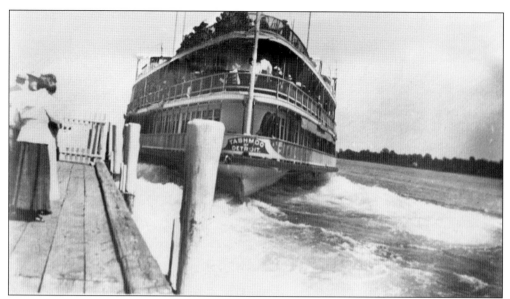

LEAVING JOE BEDORE'S. In this 1912 image, the steamer *Tashmoo* is pulling away from the dock at Joe Bedore's Hotel and heading off for the park. Note the turbulence of the water from the two paddle wheels as the steamer heads out into the river. (Courtesy of Robert Kowalski.)

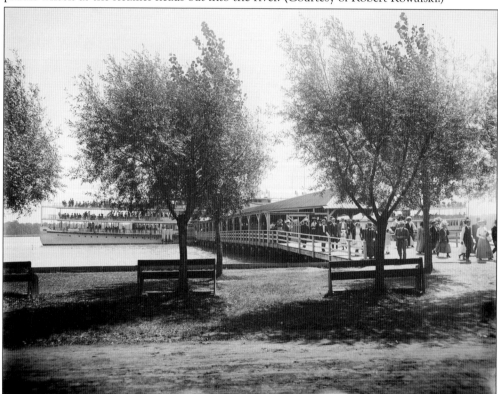

A SUNNY DAY. These visitors have just arrived and are headed off to the park in this c. 1915 photograph. In just a few minutes, the *Tashmoo* will be on her way upriver. (Courtesy of Detroit Publishing Company, Library of Congress.)

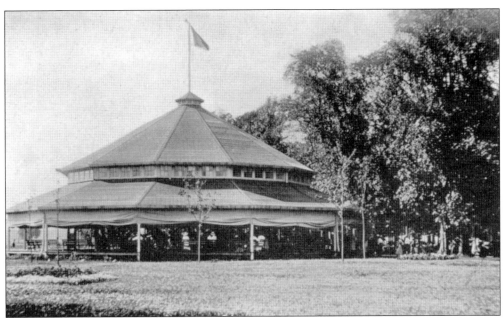

THE MERRY-GO-ROUND. Pictured here in 1916 is the beloved merry-go-round at Tashmoo Park. A menagerie of all species, colors, and sizes was to be found on this elegant steam carousel. As the platform turned slowly around, the animals affixed to the posts went up and down in a galloping motion to music played on a steam calliope. (Courtesy of SMM Collection.)

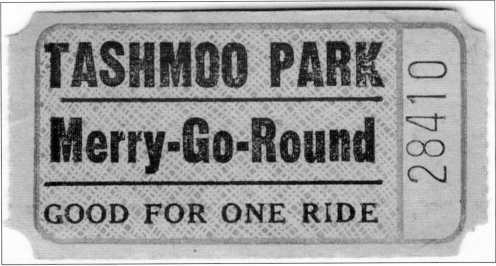

A TICKET FOR THE MERRY-GO-ROUND. The merry-go-round was one of the favorite attractions. Installed shortly after the park opened, it remained popular until 1944, when it was dismantled and sold at auction in New York. (Courtesy of Michele Komar.)

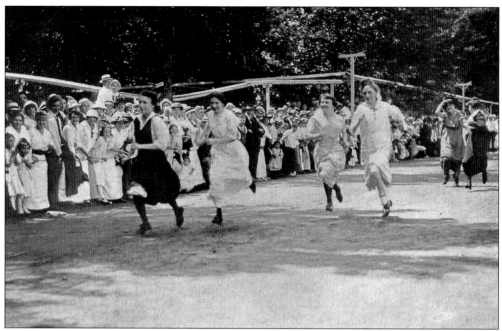

GIRLS RACE AT TASHMOO PARK. Races were popular pastimes for visitors to the park, particularly for large group outings. The young lady in the dark dress leading this race seems very determined. The two women running well back will probably not win the race but seem to be thoroughly enjoying themselves. (Courtesy of Erik Hall.)

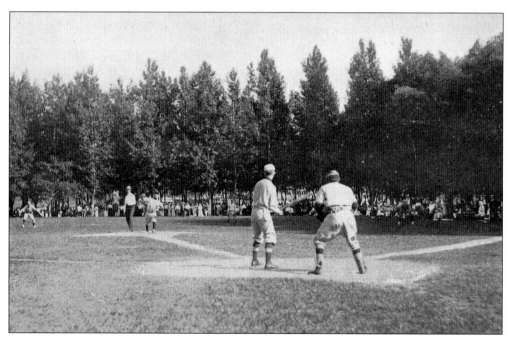

THE NATIONAL GAME. Baseball was played every day at Tashmoo Park. In this image, a runner leads off second base as the pitcher delivers his next throw. Note the umpire in a straw hat making calls from behind the mound. (Courtesy of Erik Hall.)

CAN I GO FOR A SWING? Swings and slides were an important part of a fun-filled day at Tashmoo Park, as this photograph clearly shows. The dance pavilion is in the background. It is believed that some of these swing sets wound up at the Island Elementary School after the park closed. (Courtesy of Michele Komar.)

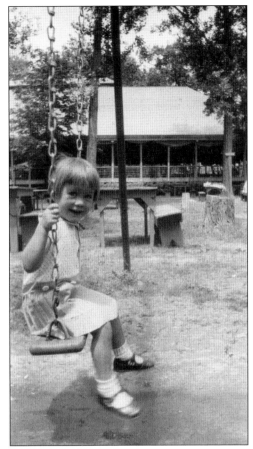

THE NURSERY AT TASHMOO PARK. For the convenience of young mothers with small children (and grandparents as well) the park provided this rather handsome building seen in this 1902 photograph. Enlarged and remodeled, this structure, now a private residence, still stands (see page 125). (Courtesy of SMM Collection.)

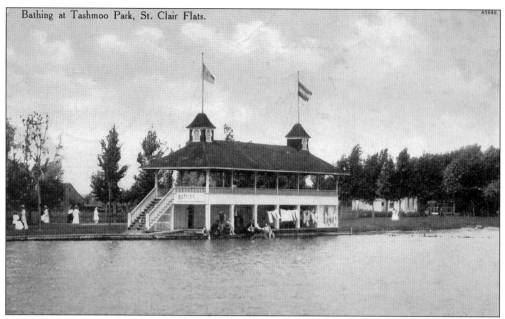

THE BATHHOUSE. Located just upriver from the landing, this bathhouse, where visitors could rent swimsuits and towels, was constructed in the same architectural style as the park's other major buildings and featured shingled cupolas. The upper floor was for watching swimmers, and the ground floor contained the changing rooms. Note the towels hanging out to dry. (Courtesy of Gary Grout.)

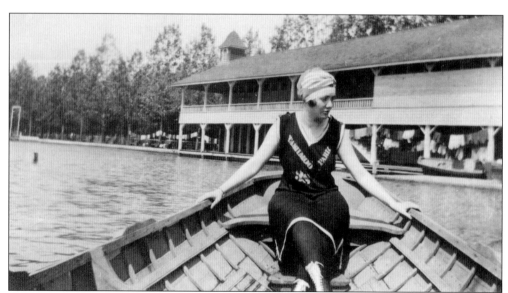

IS SHE GOING IN? This young lady sits in one of the park's rowboats in front of the bathhouse. This image, taken in the 1920s, presents the popular garb of the day, including a rented suit, cap, stockings, and laced boots. (Courtesy of Michele Komar.)

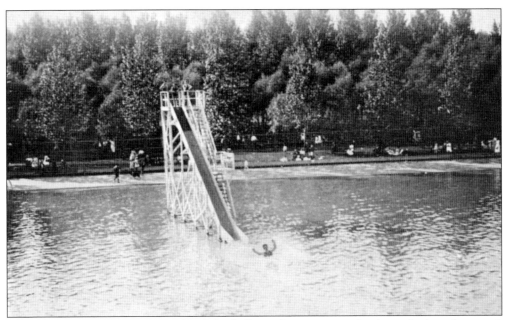

SLIDE AT THE BATHING BEACH. This slide challenged swimmers with a long climb to the top. A young man hits the water as his three friends await their turns at the top of the slide. (Courtesy of Erik Hall.)

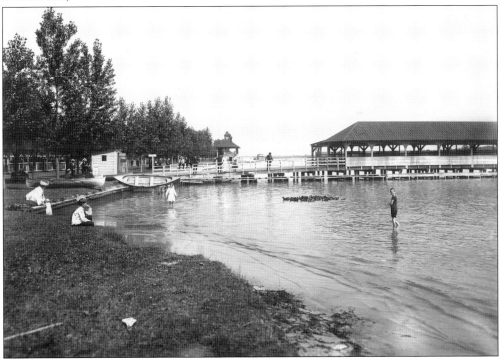

THE DUCKS IN THE WATER. Watching a good-sized group of ducks, these children are wading in the river near the boat rental shed. The boat rental was just the other side of the main landing from the bathing beach. Note the bathhouse in the distance. (Courtesy of Detroit Publishing Company, Library of Congress.)

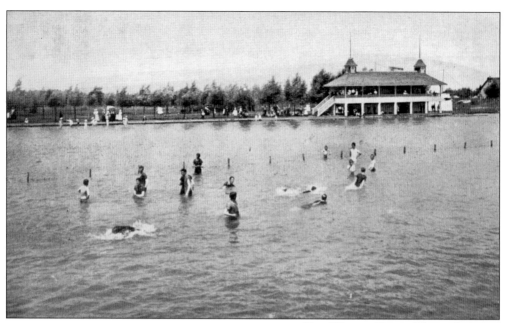

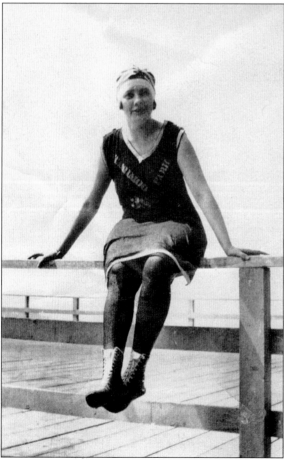

THE WADING POND. The wading pond for young children was the area behind the wire fence. One small boy can be seen hanging on the fence, wishing he could swim with the big kids. The bathhouse is to the right, and children can be seen wading close to shore on the left. (Courtesy of Erik Hall.)

A PARK SWIMSUIT. This young lady seated on the railing of the landing dock is modeling one of the park's swimsuits. These rented bathing costumes were made of heavy navy blue cotton, and "Tashmoo Park" and a number were stenciled across the front. Note the stockings and laced boots, also rented. (Courtesy of Michele Komar.)

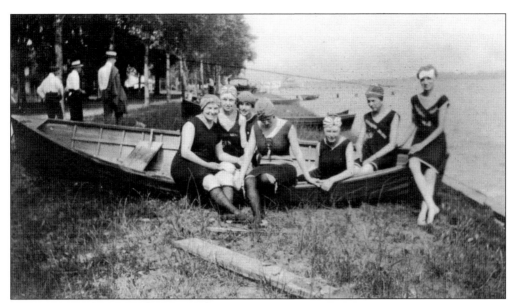

Is it Time for a Swim? This group of women sits on one of the park's rental rowboats. Some of the ladies are wearing rental swimsuits, while others have donned their own swimsuits. Notice the lady at the far left is quite daring—her stockings are rolled down, while the girl on the far right has no stockings on at all. (Courtesy of Michele Komar.)

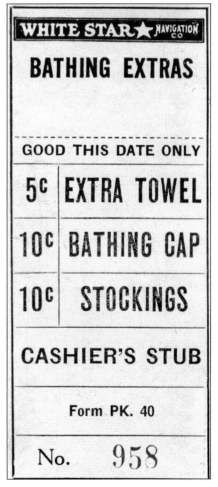

WHITE STAR ★ NAVIGATION CO

BATHING EXTRAS

GOOD THIS DATE ONLY

5¢	EXTRA TOWEL
10¢	BATHING CAP
10¢	STOCKINGS

CASHIER'S STUB

Form PK. 40

No. 958

Extra Towels are Available. If one needed an extra towel, bathing cap, or pair of stockings for swimming, he or she could purchase this ticket from the park's cashier and present the stub at the bathhouse for the items requested. (Courtesy of Michele Komar.)

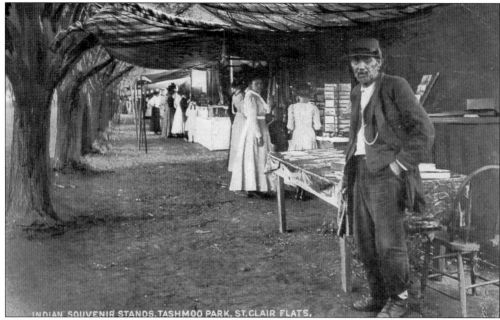

INDIAN SOUVENIR STAND. Shopping for souvenirs was a popular attraction at Tashmoo Park, and this was especially true if it was a souvenir from one of the stands belonging to the Indians from Walpole Island. (Courtesy of Gary Grout.)

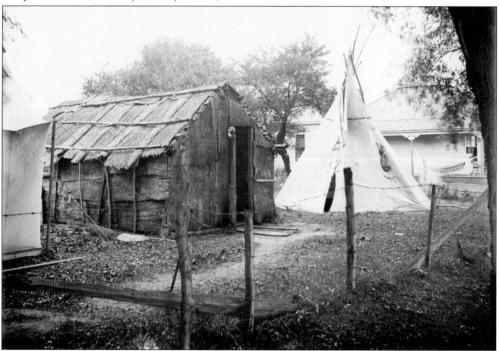

INDIAN ENCAMPMENT. Located just across the St. Clair River from Tashmoo Park is Walpole Island. The island, located in Canada, is a reservation for a community of First Nations people. These First Nations people maintained this encampment for visitors to Tashmoo Park. (Courtesy of Detroit Publishing Company, Library of Congress.)

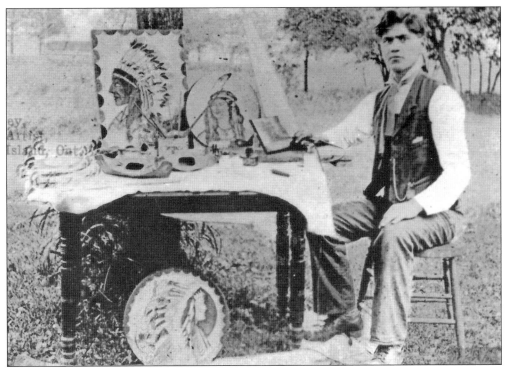

YOUNG MAN FROM WALPOLE ISLAND. This young man has a variety of handcrafted souvenirs for sale. The sale of souvenirs was an important industry for the First Nations people of Walpole Island. (Courtesy of Erik Hall.)

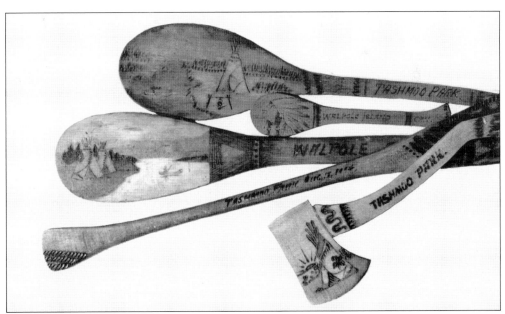

INDIAN SOUVENIRS. These wooden implements are a sample of the unique items sold by First Nations people at Tashmoo Park. These handcrafted items date back to the early 1930s. (Courtesy of Barb Crown.)

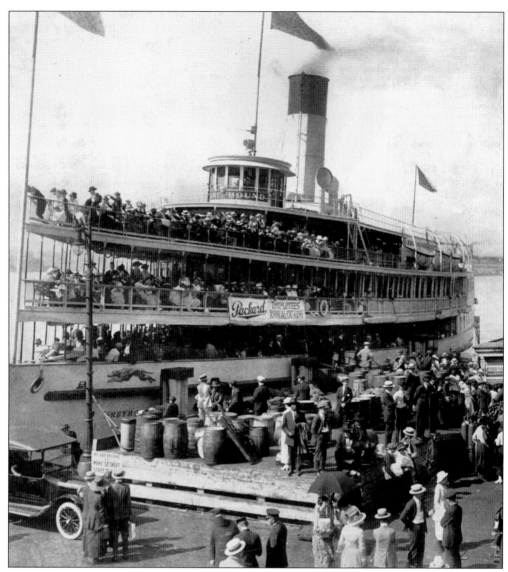

PACKARD EMPLOYEES OUTING. Chartered company trips were regular events at Tashmoo Park. Some were so large that multiple steamers—even those from competing lines, like the Bob-lo boats or the *Put-in-Bay*—would be called into service for the day's outing. Here, employees of the Packard Motor Car Company are aboard the steamer *Greyhound* on their way to the company's ninth annual outing at the park on June 21, 1919. (Courtesy of Erik Hall.)

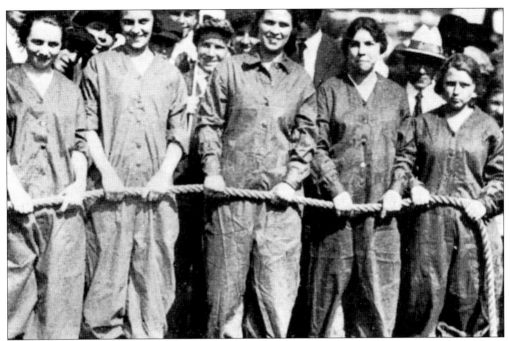

GIRLS' TUG-OF-WAR. Various sporting events were frequently an important part of any employee outing at Tashmoo Park. Here, the winners of the girls' tug-of-war team pose for the photographer at the Packard Motor Car Company excursion. (Courtesy of Erik Hall.)

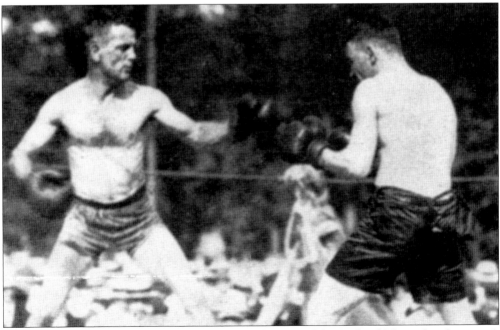

BOXING MATCH. Among the many activities held at one of the Packard Motor Car Company's employee excursions was this boxing match with "Mickey and Gilmore mixing it up." (Courtesy of Erik Hall.)

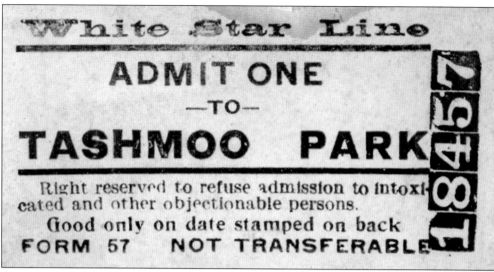

PARK ADMISSION. Beginning in the 1930s, guests could visit the park even if they did not arrive aboard one of the White Star Line steamers. This ticket was for a single admission "good only on date stamped on back." In keeping with the theme of encouraging families to visit, the company reserved the right "to refuse admission to intoxicated . . . persons." (Courtesy of Michele Komar.)

ADMIT BEARER TO

TASHMOO PARK

St. Paul's Lutheran Choir's

ANNUAL PIC-NIC

Sunday, July 10th, 1932

NOTE THIS TICKET IS TO BE USED FOR IDENTIFICATION ONLY.

ANNUAL PICNIC. Along with company employee associations, the White Star Line encouraged church groups to host their outings at Tashmoo Park. Here is a ticket for the St. Paul's Lutheran Church Choir's annual "pic-nic." (Courtesy of Michele Komar.)

MERCHANT'S TICKET
FREE CHANCE
LINCOLN PARK DAY
TASHMOO PARK
AUGUST 16, 1934
SPONSORED BY
The Lincoln Park Exchange Club

056513

GLOBE TICKET COMPANY, PHILADELPHIA

LINCOLN PARK DAY. In addition to company, fraternal, and church groups, the White Star Line hosted social groups at the park. After a pleasant ride aboard the steamer *Tashmoo*, the Lincoln Park Exchange Club hosted Lincoln Park Day at Tashmoo Park. (Courtesy of Michele Komar.)

THE A. H. PUGH PTG. CO., CIN'TI. O.

WHITE STAR ★ NAVIGATION CO.

IDENTIFICATION STUB Form 21

COMMUTORS SPECIAL RATE TICKET

GOOD ONLY FOR PASSAGE OF PURCHASER.

— — — — — — — — — — — — — — — — — — —
SIGNATURE

THE COUPONS ATTACHED TO THIS STUB ARE NOT GOOD FOR PASSAGE *N. F. MacLean* OR REFUND IF DETACHED. General Passenger Agent.

These Tickets Good, But Not on sale, Sundays or Holidays.

WHITE STAR ★ NAVIGATION CO.

BETWEEN
DETROIT GOOD EITHER DIRECTION DURING PRESENT SEASON
AND OF NAVIGATION.
ST. CLAIR FLATS or **HARSEN'S ISLAND**

10

684

Form 21 NOT GOOD IF DETACHED.

COMMUTERS TICKET. Along with visits to Tashmoo Park, the company, now called the White Star Navigation Company, sold tickets, such as the one pictured here, at a discount to individuals traveling aboard the company's steamers to one of the many other stops. (Courtesy of Michele Komar.)

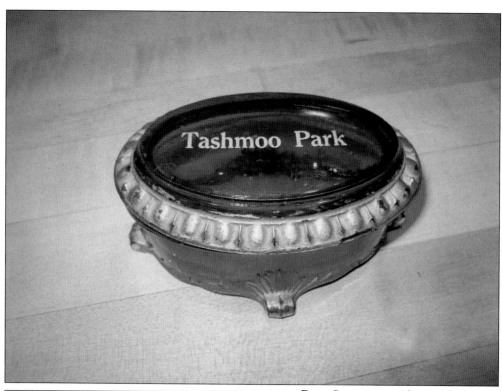

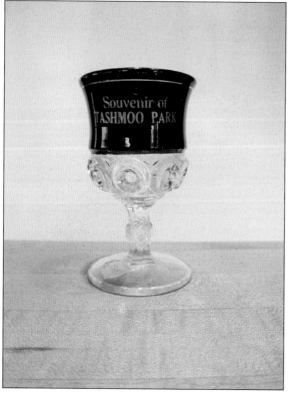

PARK SOUVENIRS. Along with the souvenirs sold by the Indians from Walpole Island, visitors could purchase a variety of glassware items. This bowl has a deep-green glass cover that has been stamped in gold with the words "Tashmoo Park." (Courtesy of John and Marie Eidt.)

GLASS GOBLET. The upper portion of this glass goblet is a deep burgundy in color and, like the other items pictured here, has been stamped with "Souvenir of Tashmoo Park." The goblet matches the glass mug in the following image. (Courtesy of John and Marie Eidt.)

GLASS MUG. This glass mug matches the stemmed glass in the preceding image in color and style. Because of the color, this type of glass is known as Ruby Flash Glass. Sold in great quantities in the 1930s, these items are valued by collectors today. (Courtesy of John and Marie Eidt.)

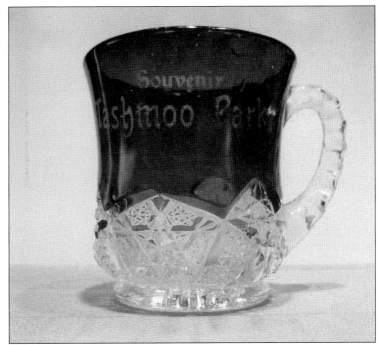

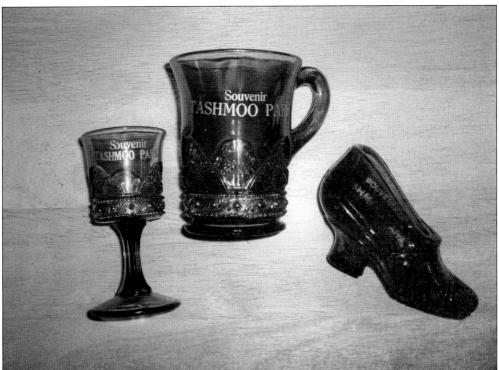

GREEN GLASSWARE. These three souvenirs of Tashmoo Park—a stemmed goblet, a mug, and a glass slipper—are all of the same deep-green color with matching gold trim and gold lettering. Like the other glass souvenirs pictured on these pages, these items are now considered prized collectibles. (Courtesy of Ruth and Ken Roth.)

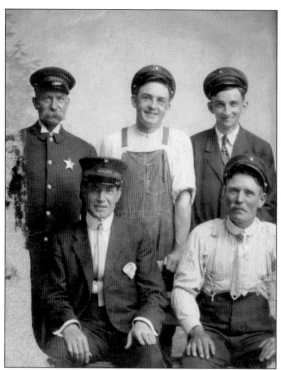

FIVE MEN FROM THE PARK. This formal portrait, believed to date back prior to 1920, is of five Tashmoo Park employees. Seated on the right is William Harm Sr., park superintendent. He retired at the end of the 1920 season, and his son William Jr., standing in the center, took over management from the spring of 1921 to 1945. Unfortunately, the other men in the image are unidentified, but the two to the left are park deputies. (Courtesy of Michele Komar.)

A GROUP PORTRAIT. A group of park employees poses for a studio portrait (note the backdrop). Pipes, cigarettes, and cigars are all in evidence, and one has to wonder who the young lady is amongst all these men. (Courtesy of Michele Komar.)

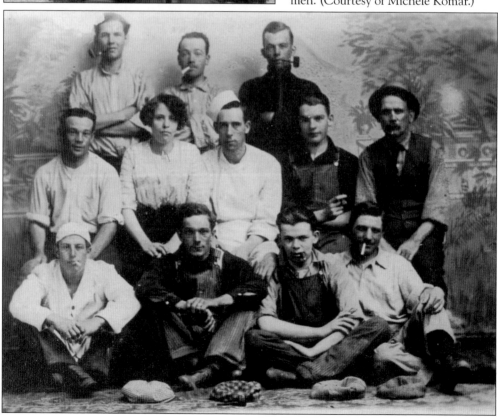

BREAK TIME. Pictured are two of the cooks during a break from their busy day at Tashmoo Park. The kitchen for all the food preparation at the park was located in the casino pavilion. (Courtesy of Michele Komar.)

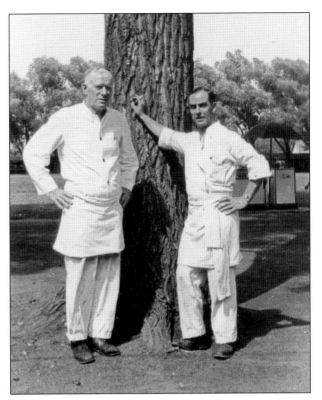

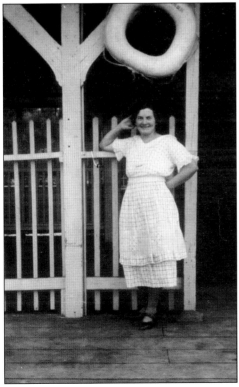

A PICTURE ON THE DOCK. Minnie Harm, wife of park superintendent Bill Harm, pauses from her busy day for a moment for this photograph on the main dock landing. This image, like the one above, dates from the 1930s. (Courtesy of Michele Komar.)

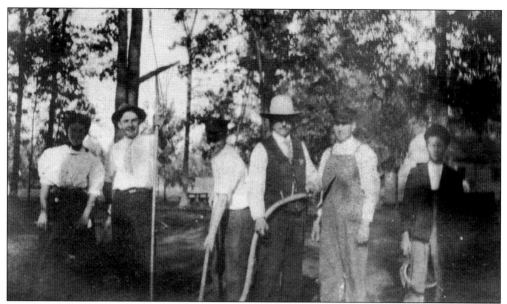

GRASS-CUTTING CREW. During the early days of the park, the grass was cut by hand, as there were no power lawn mowers in those days. In this pre-1920 photograph, the grass-cutting crew works with long-handled rakes. The man in the center uses a large scythe, while the boy to the right holds a hand scythe. (Courtesy of Michele Komar.)

THE PARK SWINGS. This image was captured either during fall or early spring. These swings were placed throughout the park, and all the park's benches, tables, and swings were stored inside the casino and the dance pavilion (separate buildings) during the winter. Each spring, they were all pulled out of storage and given a fresh coat of green paint. (Courtesy of Michele Komar.)

WHITE STAR ★ NAVIGATION CO.

—— TASHMOO TRANSIT COMPANY, LESSEE ——

1933

No. 245

ASS Mr. Wm. Harm, Jr.,
Superintendent
Tashmoo Park

OD DURING CURRENT YEAR SUBJECT TO CONDITIONS ON BACK
LID WHEN COUNTERSIGNED BY C. F. BIELMAN, JR. OR N. F. MacLEAN

COUNTERSIGNED

PRESIDENT

THE SUPERINTENDENT'S PASS. Each year, the park's superintendent and his family were issued a pass that enabled them to ride the steamer *Tashmoo* for free. Dated for the year 1933, this pass shows the company's change of name. The steamer, now the company's only vessel, was leased by the Tashmoo Transit Company from the White Star Navigation Company. (Courtesy of Michele Komar.)

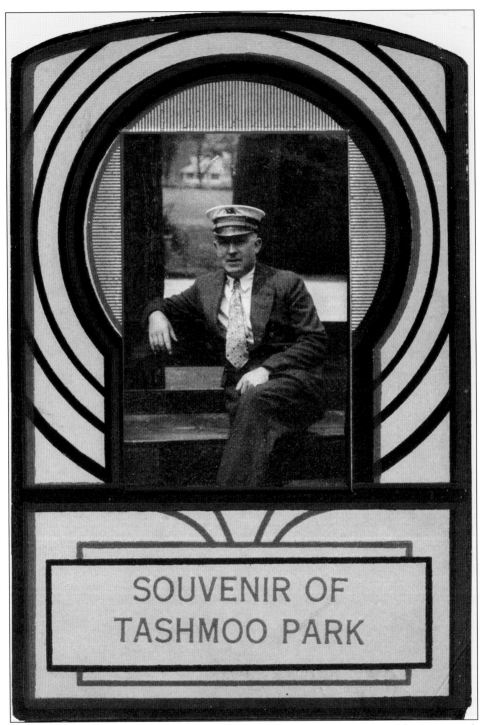

SOUVENIR OF
TASHMOO PARK

THE PARK'S SUPERINTENDENT. This is William Harm Jr., who took over as park superintendent when his father retired in 1921. A park photographer roved the grounds, taking candid shots and producing images such as this one, which were mounted and sold in a variety of "Souvenir of Tashmoo Park" frames. (Courtesy of Michele Komar.)

Four

THE STEAMER

With the opening of its new park, the White Star Line quickly moved forward with plans for a new excursion steamer that would service the Detroit-to-Port Huron run and, particularly, Tashmoo Park. On January 13, 1899, an article appeared in the *Detroit Free Press* reporting that the steamer would be built at the Wyandotte yard of the Detroit Shipbuilding Company and designed by Detroit's noted marine architect Frank E. Kirby. On March 27, 1899, the keel was laid for the ship that would be christened the *Tashmoo*. Work on the hull began immediately, and on December 30, 1899, the next-to-last day of the old century, the *Tashmoo* was launched. The hull was towed to the Orleans Street yard of the Detroit Shipbuilding Company, where her engines, boilers, and superstructure were installed. The steamer completed her trial runs in May and entered service in June 1900. From the very beginning, the *Tashmoo* was the most recognized and, possibly, the most photographed day boat on the Detroit waterfront. For the next 36 years, the "Glass Hack," as she was often affectionately called because of her near endless rows of windows, would sail from her dock at the foot of Griswold Street up to the Flats, Tashmoo Park, and on to Port Huron. Her schedule was so regular and precise, residents of the Flats and Harsens Island would set their clocks by her arrivals and departures. She would carry presidents, admirals, mayors, business tycoons, and thousands of other passengers until that fateful night of June 18, 1936.

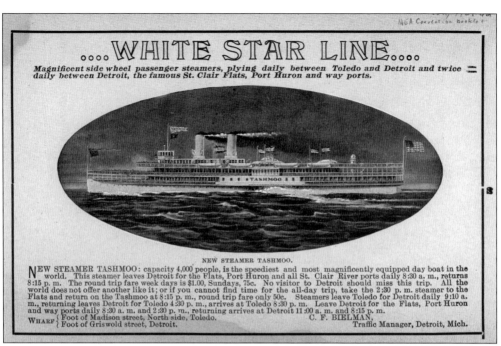

A MAGNIFICENT EXCURSION STEAMER. While the White Star Line's new steamer was under construction, the company began an active advertising campaign. With ads such as the one shown here, the company had ample time to announce the coming of its magnificent excursion steamer, the *Tashmoo*. (Courtesy of SMM Collection.)

FRANK E. KIRBY. As early as 1897, the White Star Line considered building a new steel steamer. Finally, in 1898, noted marine architect Frank E. Kirby began to produce drawings for the new vessel. The 49-year-old engineer was then at the height of his career, and his design did not disappoint. (Courtesy of SMM Collection.)

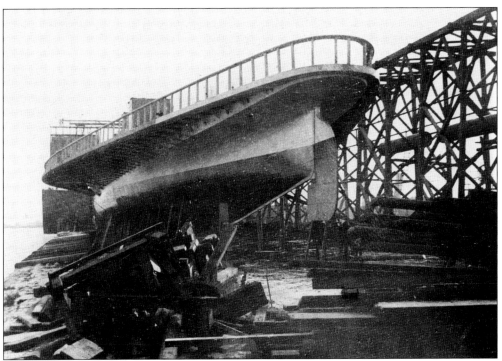

THE NEW VESSEL TAKES SHAPE. In 1899, shipyards on the lakes experienced an extended shortage of steel plates due in part to the lingering result of the Panic of 1893 combined with the massive changeover underway, of older wooden shipbuilders on the Great Lakes to shipyards producing steel vessels. After much delay, the keel was laid on March 27, 1899. (Courtesy of SMM Collection.)

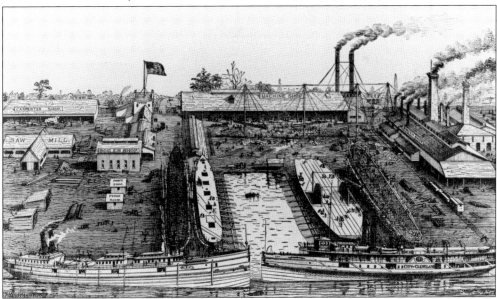

THE WYANDOTTE YARDS. The new steamer was built at this yard in Wyandotte. This city became known as an important center for metal shipbuilding following the Civil War. The yard would remain until the last hull was launched there in October 1920. This is a drawing of the yard as it looked in 1884 by marine artist Seth A. Whipple. (Courtesy of author's collection.)

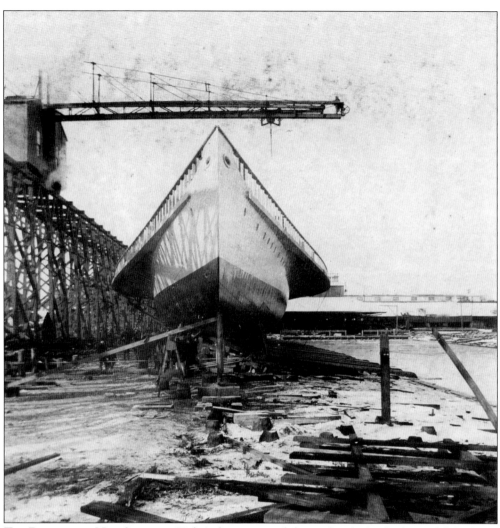

THE BOW OF THE NEW STEAMER. Kirby's design proved the perfect fit for the beautiful day boat. When completed, the *Tashmoo* would have four decks—(from lowest to highest) the orlop, the main, the promenade, and the hurricane. She would measure 320 feet in length overall, 300 feet on the waterline, 37 feet and 6 inches wide, and 69 feet wide at the point where the housing for her paddle boxes was located. Her slim, canoe-like hull was 13 feet and 6 inches deep, and she drew only 8 feet of water. Her paddle wheels were 22 feet, 4 inches in diameter and had blades 12 feet across. Here five coal-fed boilers produced 170 pounds of steam per inch, and her new inclined engines gave the boat a regular top speed of 18 to 20 miles per hour. While the *Tashmoo* was designed to carry 4,000 passengers, her owners applied to the steamboat service for a full load of only 3,000 people for comfort and safety's sake. The boat was indeed the pride of the Detroit waterfront. (Courtesy of SMM Collection)

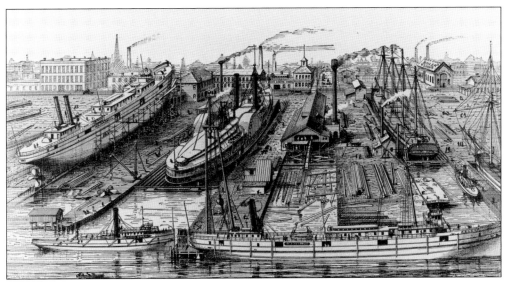

THE ORLEANS STREET YARD. Following the launch of the new steamer, the hull was towed up to Detroit to receive her engines, cabins, and all the finish work required to make a first-class steamer. This yard of the Detroit Shipbuilding Company, shown here in 1884, was located on the city's east side waterfront at the foot of Orleans Street. (Courtesy of author's collection.)

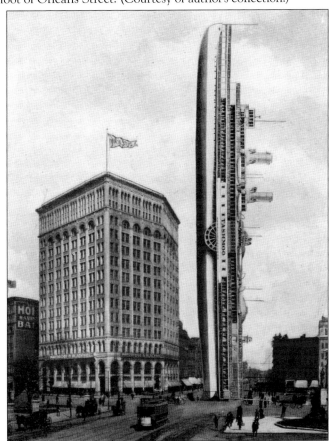

TALLER THAN THE MAJESTIC. Constructed in 1896, the Majestic Building was Detroit's first skyscraper. The structure boasted 14 stories and stood just over 223 feet tall. For comparison, the White Star Line did not hesitate mentioning that its new flagship was 109 feet longer than the famed building was tall and seemingly had more windows. While accounts vary, most agree that the steamer had at least 600 windows. (Courtesy of SMM Collection.)

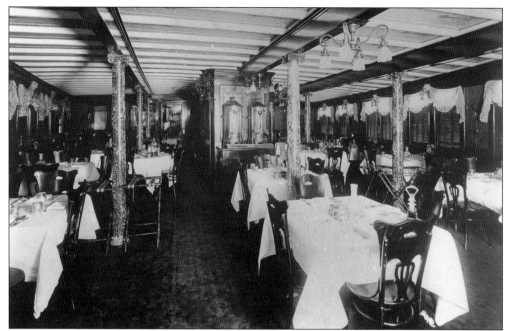

MAIN DINING ROOM. While at the Orleans Street yard, the steamer's interior work was completed. No expense was spared, as evidenced in this series of views. Here is the mahogany-paneled dining room on the main deck, aft, looking forward. Note the specially crafted marbleized columns. (Courtesy of SMM Collection.)

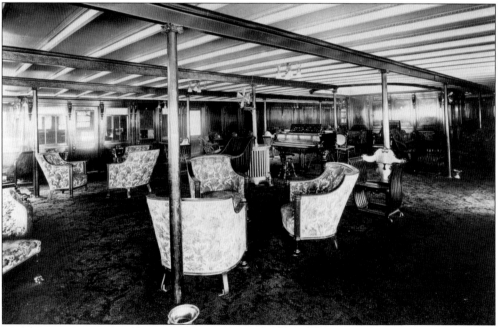

MAIN SALON. Located on the promenade deck (above the main deck), the main salon, seen in this aft-facing view, included elaborate Wilton carpeting, richly upholstered lounge furniture, and a grand piano. No detail to the comfort of the passengers was spared. Note the fine brass spittoons discretely placed at the base of the columns. (Courtesy of SMM Collection.)

PRIVATE PARLORS. For comfort and privacy, there were eight finely appointed private parlors, such as this one, located four to each side on the promenade deck, flanking the main salon. (Courtesy of SMM Collection.)

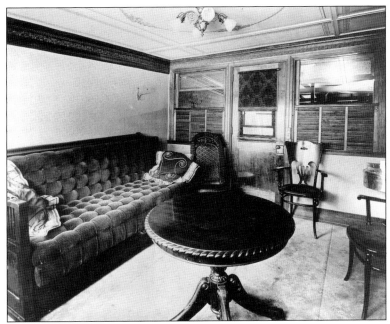

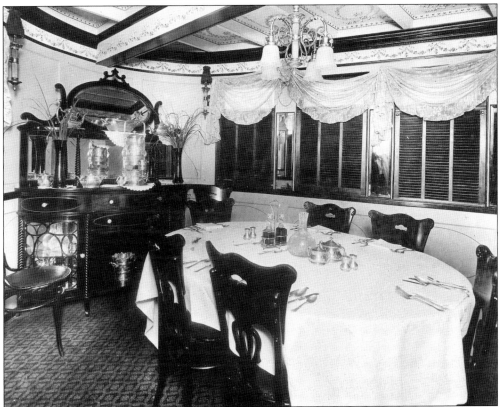

PRIVATE DINING ROOM. Along with private parlors, there was a richly furnished private dining room at the stern of the main deck. It was here that Pres. Theodore Roosevelt would be served lunch on September 22, 1902, during his trip on the steamer. (Courtesy of SMM Collection.)

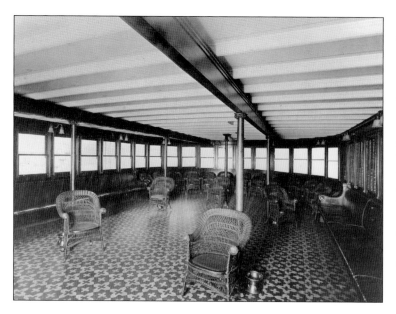

SMOKING ROOM. This smoking room, located on the hurricane deck (the top deck), was finished in chestnut-stained olive green. Seating included finished wooden benches below the windows, as well as comfortable wicker chairs. Brass spittoons, of course, were also included. (Courtesy of SMM Collection.)

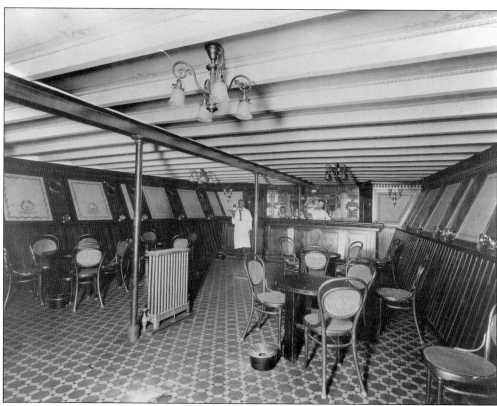

BEER GARDEN. On a trip up the river, a man could work up a thirst and stroll down to the beer garden, which was located forward on the orlop deck (lowest deck), for a glass or two from one of Detroit's many fine breweries. (Courtesy of SMM Collection.)

SNACK BAR.
Refreshments could also be obtained at this snack bar. The room was finished in oak and located on the main deck just aft of the engine room, which can be seen through the open window at the left. (Courtesy of SMM Collection.)

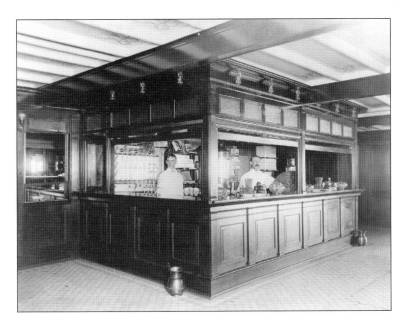

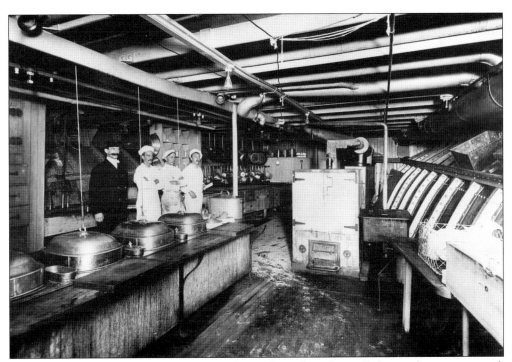

THE GALLEY. Located aft on the orlop deck was the galley where all the meals were prepared. Everything is in good order, the needed pots and pans line the far bulkhead, and the staff is ready for the arrival of passengers and the start of its busy day. (Courtesy of SMM Collection.)

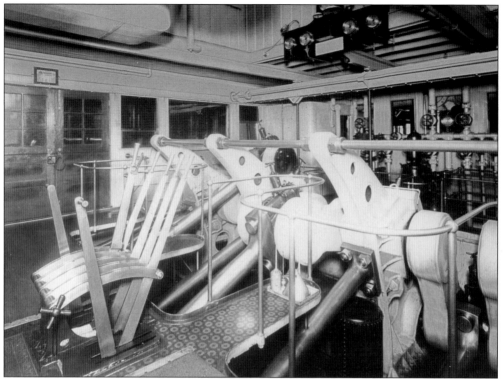

ENGINE ROOM. Here is a photograph of the main engine room. All is clean and quiet in this view, but soon passengers would board, the captain would call for preparations to get underway, and the room would quickly become one of the busiest, and certainly loudest, spaces aboard. (Courtesy of SMM Collection.)

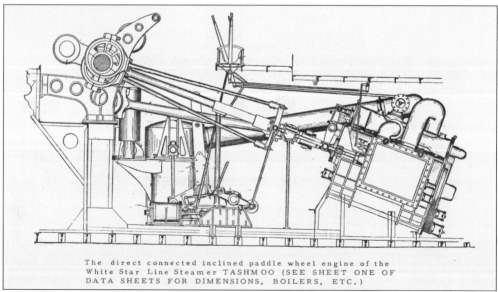

The direct connected inclined paddle wheel engine of the White Star Line Steamer TASHMOO (SEE SHEET ONE OF DATA SHEETS FOR DIMENSIONS, BOILERS, ETC.)

ENGINE DRAWING. Here is an engineering drawing of the *Tashmoo's* "direct connected incline paddle wheel engine." The control levers at the top of this illustration can be clearly seen in the forefront of the photograph at the top of this page. (Courtesy of SMM Collection.)

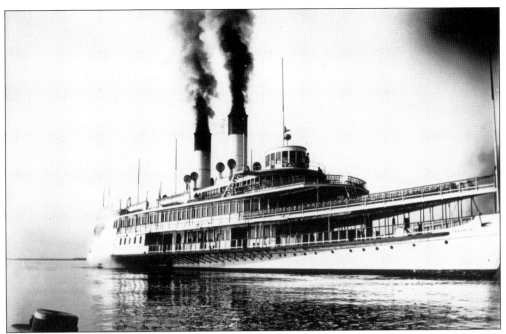

TRIAL RUNS. Two trial runs were taken for the steamer. The first on May 14, 1900, was held on Lake St. Clair to fine-tune the engines and small mechanical details. The second, the Owner's Acceptance Trial, shown here on May 27, was conducted on the Detroit River. All went well, and the *Tashmoo* was officially turned over to its owners. (Courtesy of SMM collection.)

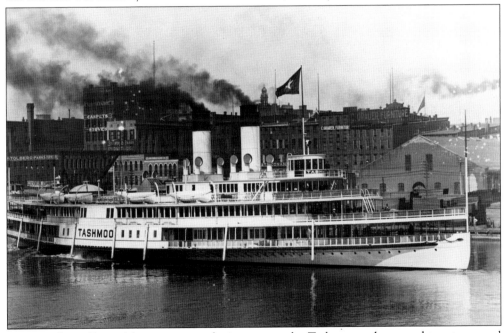

TOUR ON LAKE ERIE. After acceptance by its owners, the *Tashmoo* made a grand tour to several ports on Lake Erie. In this photograph, the steamer is leaving Toledo and heading back to Detroit. It is rumored that President McKinley may have seen the *Tashmoo* during her stop in Cleveland, though no documentation of this has been found. (Courtesy of SMM Collection.)

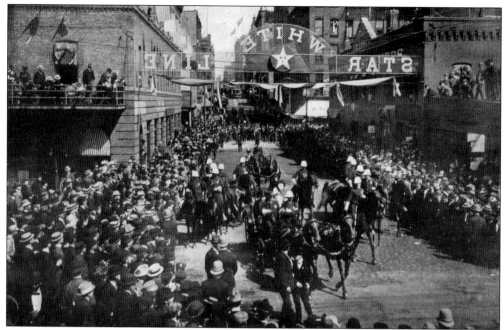

ADM. GEORGE DEWEY VISITS DETROIT. Before the formal first season for the newest steamer on the river began, the *Tashmoo* and the city of Detroit welcomed one of the country's newest heroes. On June 9, 1900, Adm. George and Mildred Dewey are seen here arriving at the White Star Line dock. (Courtesy of SMM Collection.)

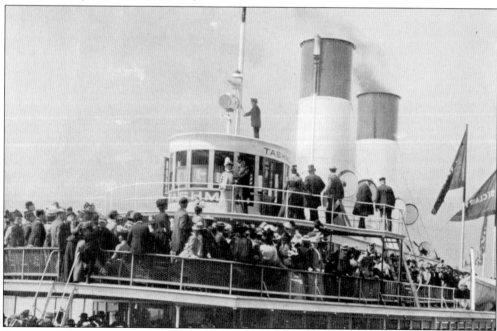

ABOARD THE TASHMOO. Admiral and Mrs. Dewey are seen on the pilothouse bridge of the *Tashmoo* just before the start of the parade. The steamer would soon be underway to provide the hero of the Battle of Manila Bay a fine tour of the Detroit River and the city's waterfront. (Courtesy of SMM Collection.)

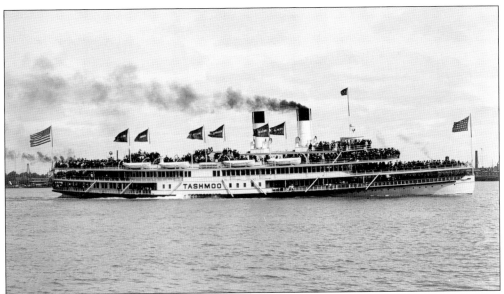

GRAND PARADE. Aboard the *Tashmoo*, Admiral Dewey leads the naval parade on the Detroit River. With flags flying, including his personal pennant seen on the mast above the pilothouse, Dewey "took command" of the flotilla. (Courtesy of SMM Collection.)

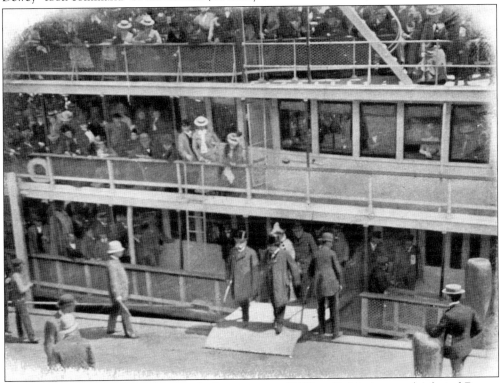

END OF A GRAND DAY After the parade, Detroit mayor William C. Maybury and Admiral Dewey are seen leaving the *Tashmoo*. It was a grand day for the city and for the *Tashmoo*, though it appears the new steamer was loaded well above her capacity of 4,000 passengers. (Courtesy of SMM Collection.)

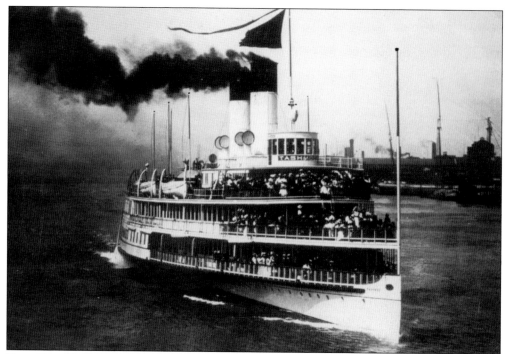

FIRST TRIP. With all the formalities and celebrities gone, the *Tashmoo* finally began her first season officially on June 11, 1900. In this image, she has just departed the Griswold Street dock and is heading up to the Flats and Harsens Island, thus starting a tradition that would last for over 35 years. (Courtesy of SMM Collection.)

IN DRY DOCK. During the winter of 1900–1901, the *Tashmoo* was taken back to the Orleans Street yard for a number of minor changes. The main improvement was to extend the hurricane deck fully forward. This was done largely to provide additional viewing room (and less crowding) for passengers. (Courtesy of SMM Collection.)

Builders of the new Steel Steamer "Tashmoo," the largest, speediest and most elegantly equipped day boat in the United States.

ALEXANDER McVITTIE,
President and Manager.

WILLIAM C. McMILLAN,
Vice President.

CHARLES B. CALDEE,
General Superintendent.

M. E. FARR,
Secretary and Treasurer.

FRANK E. KIRBY,
Consulting Engineer.

DETROIT SHIP BUILDING COMPANY
SHIP AND ENGINE BUILDERS.

——MANUFACTURERS OF——
MARINE AND RAILWAY HARDWARE.

Sole Owners for the Lakes and Atlantic Coast of the
Howden Hot Draft System, as applied to Boilers, giving Increased Power and Great Economy...........

Steel Shipyard Located at
WYANDOTTE, MICH.

DETROIT, MICH.

Wooden Shipyard and Dry Docks Foot of
Orleans St. and Foot of Clark Ave.

THE NEW TASHMOO. The newly refined *Tashmoo* was a delight to behold and served as a "bragging rights" ship for the Detroit Shipbuilding Company. It did not hesitate using the vessel in its various advertising materials, and marine men frequently compared her to the well-known day boats of the Hudson River region. (Courtesy of SMM Collection.)

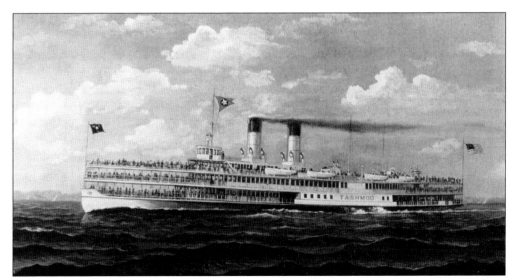

WHIPPLE PAINTING. Just after the *Tashmoo* was launched, famed Detroit marine artist Seth A. Whipple was commissioned to paint an oil portrait of the new steamer for the White Star Line. Unfortunately, just after completing this beautiful canvas, Whipple died unexpectedly on October 11, 1901, at the young age of 46. (Courtesy of SMM Collection.)

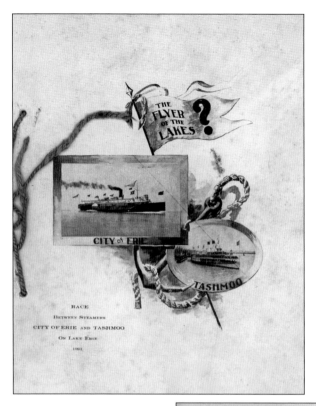

The Great Race. In the fall of 1900, White Star Line president Aaron Parker, proud of the speed of his new steamer, offered $1,000 to any boat that could beat the *Tashmoo* on the open lakes. The challenge was taken up by the Cleveland and Buffalo Transit Company's *City of Erie* for a 100-mile race (it turned out to be only 94 miles long) on Lake Erie, set for June 4, 1901. (Courtesy of SMM Collection.)

Race Souvenir. The details of the two steamers are included in this souvenir booklet, which was given to supporters asking the question of which would be the "flyer of the lakes"? The *City of Erie*, a side-wheel night boat launched in 1898, had also been designed by Frank E. Kirby. (Courtesy of SMM Collection.)

CLEVELAND & BUFFALO TRANSIT CO.,
CLEVELAND, OHIO.

T. F. NEWMAN, Genl. Manager.

DESCRIPTION OF STEAMER "CITY OF ERIE."

Displacement—Gross Tons,	2050
Length of Steamer,	324 feet
Breadth of Steamer,	78 feet
Maximum Horse Power,	6000
Trial Speed ? ? ?

WHITE STAR LINE, DETROIT, MICH.

A. A. PARKER, Prest. & Genl. Manager.

DESCRIPTION OF STEAMER "TASHMOO."

Displacement—Gross Tons,	1200
Length of Steamer,	322 feet
Breadth of Steamer,	70 feet
Maximum Horse Power,	2800
Trial Speed ? ? ?

CONDITIONS OF RACE.

Flying Start ½ mile. Cross starting line 9:30 A. M

Finish opposite Erie, Pa., at......P. M.

Distance, 100 miles.

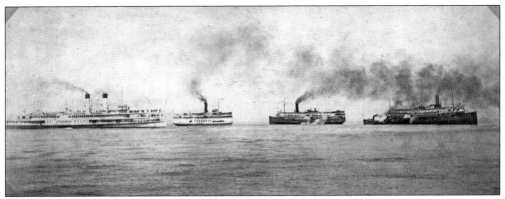

THE STARTING LINE. The *City of Erie* and the *Tashmoo*, joined by a fleet of spectators, prepare to begin the race. This was a major event on the Great Lakes and was extensively covered in all the local newspapers of the major port cities, especially Cleveland and Detroit. The boats pictured are, from left to right, the *Tashmoo*, the ferry *Promise* (loaded with visitors from Detroit), the *City of Erie*, the tug *C.A. Lorman*, and the steamer *City of Buffalo*. The tugboat is just visible at the stern of the *City of Buffalo*. (Courtesy of SMM Collection. (Courtesy of SMM Collection.)

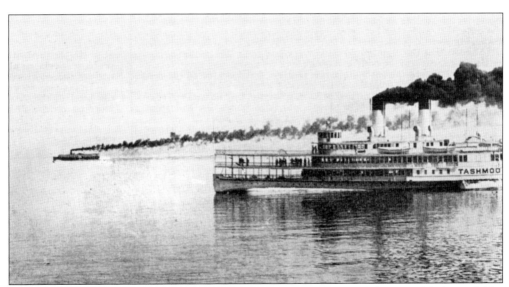

THE FINISH LINE. Even with the more modern engine and stripped down and lightened (the two grand pianos were temporarily removed, and her flags were taken down to prevent drag), the *Tashmoo*, the famed flyer of the Detroit River, did not become the flyer of the lakes. Built for shallow and sheltered waters, the *Tashmoo* was beaten out by the older *City of Erie* by a mere 45 seconds. (Courtesy of SMM Collection.)

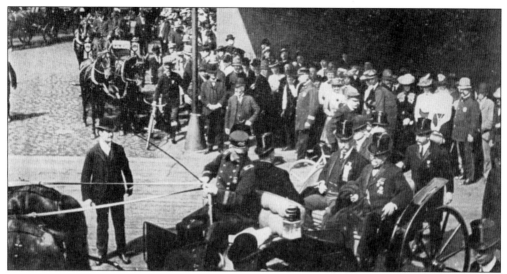

VISIT BY PRESIDENT ROOSEVELT. On September 22, 1906, the *Tashmoo* was to host another celebrity, Pres. Theodore Roosevelt. The president was in Detroit to address a convention of Spanish-American War veterans. Here, the president and Mayor William C. Maybury arrive at the dock and prepare to board the *Tashmoo.* (Courtesy of SMM Collection.)

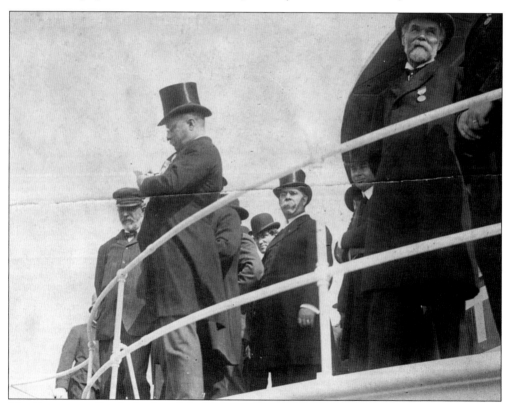

MR. PRESIDENT. On the bridge of the *Tashmoo,* President Roosevelt jots down some last-minute notes. The gentleman with the white beard to the president's left is Detroiter William Livingstone, then president of the Lake Carriers Association. (Courtesy of SMM Collection.)

Steamer "Tashmoo" Leaving Dock with President Roosevelt on Board, Detroit, Mich.

UNDERWAY. The *Tashmoo* is underway, and soon President Roosevelt (at center with hand on hip) and other dignitaries, including Livingstone, Mayor Maybury, and White Star Line president Aaron A. Parker, will adjourn to lunch in the steamer's private dining room. (Courtesy of SMM Collection.)

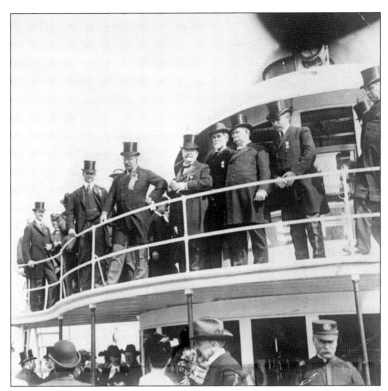

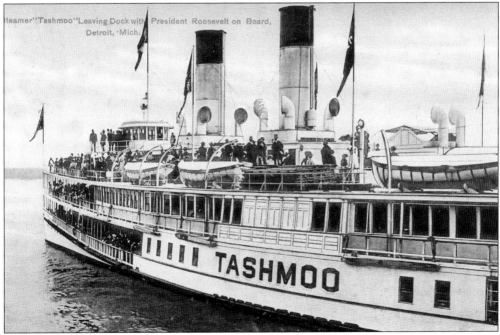

A DAY ON THE RIVER. As can been expected, the president's visit to Detroit, including his speech and trip aboard the *Tashmoo*, was an important local event. The steamer carried the party, seen in this postcard, up the Detroit River and out onto Lake St. Clair before returning to the Griswold Street dock. (Courtesy of Gary Grout.)

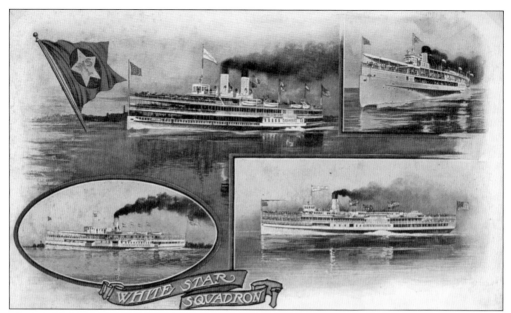

THE WHITE STAR SQUADRON. This color postcard of the White Star Line dates from about 1907. Advertising the "White Star Squadron," the image presents the flagship *Tashmoo*, along with the *Owana* (upper right), *City of Toledo* (lower left), and the new *Greyhound* (lower right). A fifth steamer, the *Wauketa*, would join the fleet in 1909. (Courtesy of Gary Grout.)

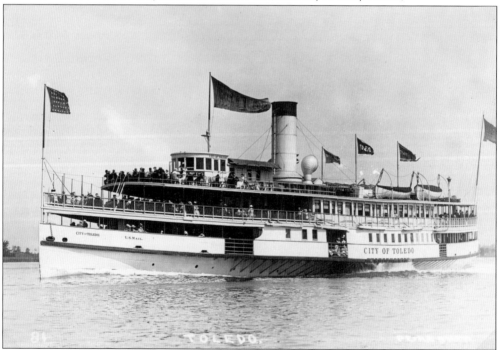

CITY OF TOLEDO. Launched in 1891, the *City of Toledo* was the first steamer to be owned by the White Star Line. In 1916, the steamer was lengthened by 40 feet and given a second dummy smokestack for ventilation purposes. The remodeled steamer was a success, and from a distance, it was hard to distinguish her from her more famous fleet mate *Tashmoo*. (Courtesy of SMM Collection.)

THE OWANA. The *Owana*, launched in 1899 and first named the *Pennsylvania*, was purchased by the White Star Line and renamed in 1905. All of the White Star Line steamers, including the *Owana*, were authorized to carry mail and had a sign somewhere on their bows saying "US Mail." (Courtesy of SMM Collection.)

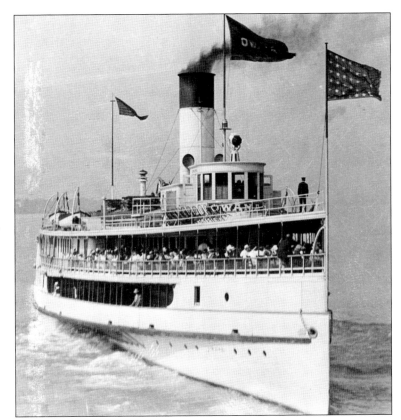

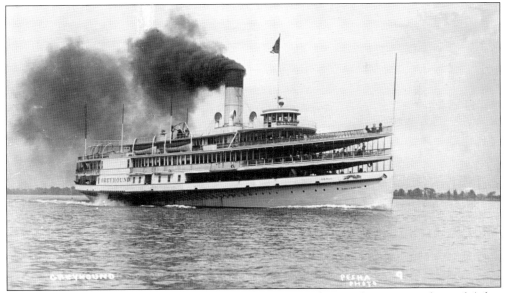

THE GREYHOUND. By 1902, the White Star Line was ready to order its second vessel (after the *Tashmoo*). This was the *Greyhound*, launched February 1902. Among the most distinctive features of the new *Greyhound* (see page 15) were the carved greyhound dogs taken from the old *Greyhound*, which were displayed running mid-stride on each side of her bow. (Courtesy of SMM Collection.)

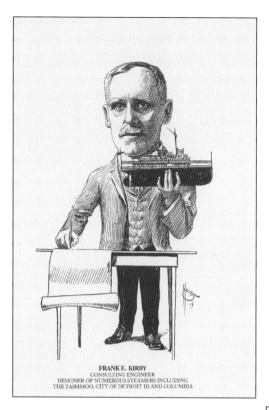

FRANK E. KIRBY
CONSULTING ENGINEER
DESIGNER OF NUMEROUS STEAMERS INCLUDING
THE TASHMOO, CITY OF DETROIT III AND COLUMBIA

FRANK E. KIRBY. In 1905, the Newspaper Cartoonists' Association of Michigan published a book of pen sketches of prominent men of Michigan. Entitled *Our Friends As We See 'Em*, the collection included four men closely involved with the *Tashmoo* and the White Star Line. Here is Frank E. Kirby, "designing engineer of numerous steamers including the *Tashmoo*." (Courtesy of St. Clair Shores Public Library.)

CHARLES F. BIELMAN SR. Astride the *Tashmoo* with binoculars in hand, Charles F. Bielman was secretary and general manager of the White Star Line. In addition to his responsibilities, Bielman was later elected to the Detroit City Council. He died in 1920 while in office. (Courtesy of St. Clair Shores Public Library.)

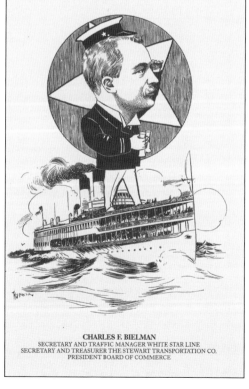

CHARLES F. BIELMAN
SECRETARY AND TRAFFIC MANAGER WHITE STAR LINE
SECRETARY AND TREASURER THE STEWART TRANSPORTATION CO.
PRESIDENT BOARD OF COMMERCE

AARON A. PARKER. Depicted astride the *Tashmoo* and the *Greyhound*, Aaron Parker, president of the White Star Line, is seen holding an image of Detroit's Dime Bank, of which he was a director. (Courtesy of St. Clair Shores Public Library.)

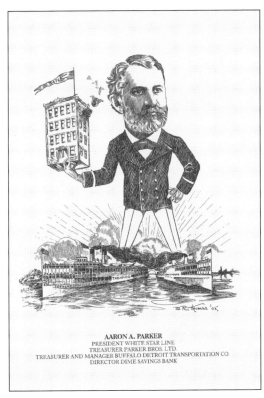

AARON A. PARKER
PRESIDENT WHITE STAR LINE
TREASURER PARKER BROS. LTD.
TREASURER AND MANAGER BUFFALO DETROIT TRANSPORTATION CO.
DIRECTOR DIME SAVINGS BANK

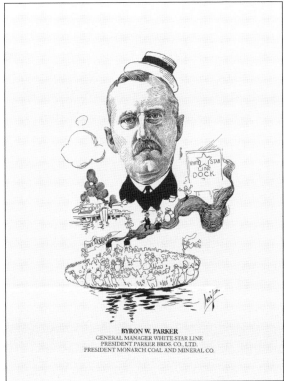

BYRON W. PARKER
GENERAL MANAGER WHITE STAR LINE
PRESIDENT PARKER BROS. CO., LTD.
PRESIDENT MONARCH COAL AND MINERAL CO.

BYRON W. PARKER. Byron Parker, general manager of the White Star Line, is seen here in straw hat with a sign for the White Star Line Dock. Like his brother Aaron, Byron Parker had a summer home on Harsens Island just upriver from Tashmoo Park. (Courtesy of St. Clair Shores Public Library.)

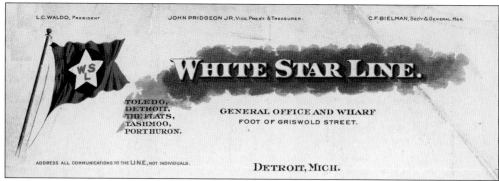

WHITE STAR LINE. By April 1920, the date of this letterhead, Charles F. Bielman Sr., secretary and general manager of the line since its inception in 1896, had died. L.C. Waldo moved from his position as a director of the board to the office of president when the Parker family interests sold out with larger blocks of stock being purchased by Detroit's Barlum family. Charles F. Bielman Jr. succeeded his father as secretary and general manager of the line. (Courtesy of SMM Collection.)

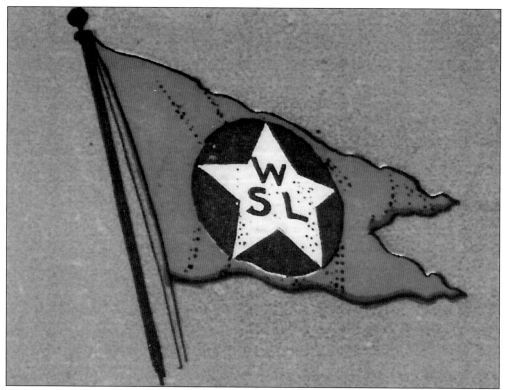

FLAG OF THE WHITE STAR LINE. The line's flag, which was flown by each of its steamers, was a red swallow-tailed pennant with a blue circle containing a white star with red letters. (Courtesy of author's collection.)

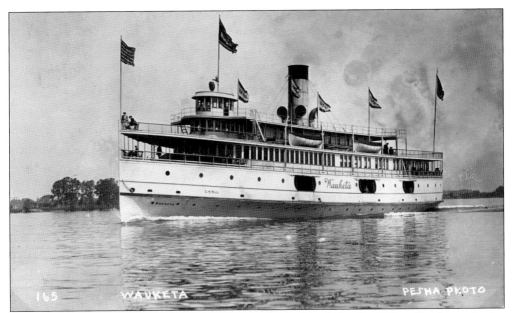

THE WAUKETA. The year 1909 would see the final vessel built for the White Star Line. As the line's only propeller (as opposed to paddle wheeler), the *Wauketa* was designed primarily as a freight boat, as the other day liners had very little room on their main decks for anything other than what the passengers would bring for a day or weekend trip. (Courtesy of SMM Collection.)

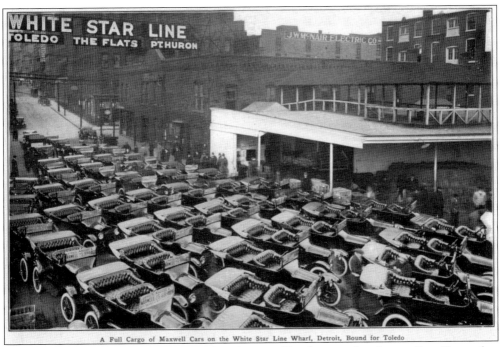

A Full Cargo of Maxwell Cars on the White Star Line Wharf, Detroit, Bound for Toledo

MAXWELL AUTOS. While the *Wauketa* found most of her business heading to Port Huron, her schedule could be switched on a moment's notice when an opportunity arose. Here is a fleet of 60 new 1915 Maxwell sedans bound for Toledo. The *Wauketa* served as a regular carrier of new automobiles between Detroit, Port Huron, and Toledo for many years. (Courtesy of SMM Collection.)

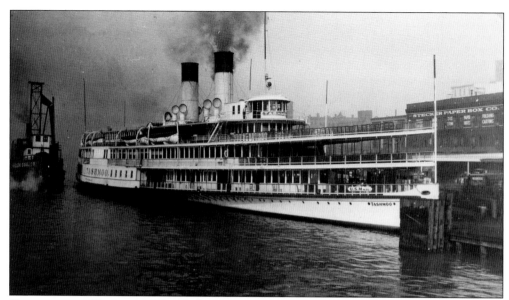

COAL FOR THE TASHMOO. The *Tashmoo* sits at the Griswold Street dock. She is awaiting a delivery of coal from the Mullen Coal Company lighter seen at left. Once the re-coaling was completed, the *Tashmoo* would be ready for her scheduled run upriver to Port Huron. (Courtesy of SMM Collection.)

GRISWOLD STREET DOCK. Most views of the *Tashmoo* at the White Star Line dock are from the waterside. This 1926 view looks down Griswold toward the river from Atwater Street. All is quiet at the moment, but soon passengers will be coming aboard, and the steamer will be off to Tashmoo Park and points north. (Courtesy of Manning Brothers.)

SOUTHERN ROUTE. By 1905, the White Star Line decided to further develop its southern route to Toledo. During that year, the company secured most of Sugar Island, located in the lower Detroit River just east of Gross Ile. The island, which was owned by the John P. Clark estate, had been used recreationally since at least the time of the Civil War. The White Star Line made numerous improvements to the existing park that echoed the style and architecture of its Tashmoo Park. (Courtesy of Michael Dixon.)

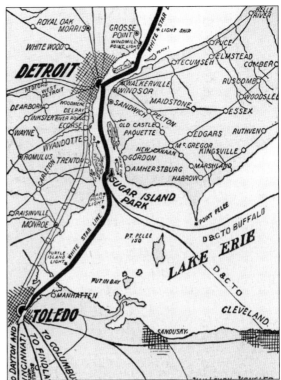

DOCK AT TOLEDO. When organized in 1896, the White Star Line developed a route that included service both up to Port Huron and downriver to Toledo. This is a 1902 view of the line's first dock, located at the foot of Madison Street. (Courtesy of SMM Collection.)

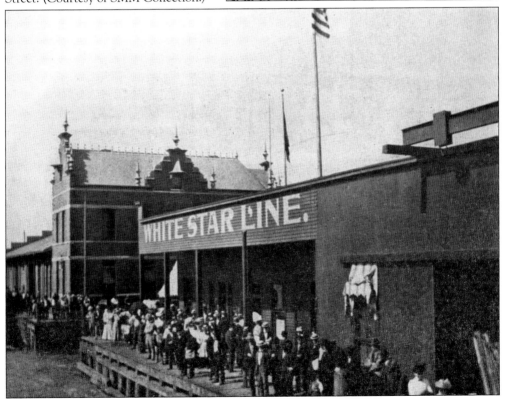

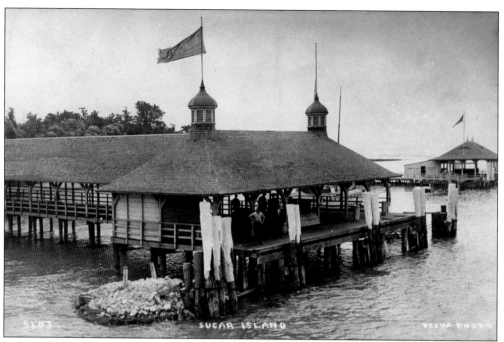

Sugar Island Landing. This view shows the main landing at Sugar Island Park. Note the similar architectural style to the landing at Tashmoo Park. To the right, only partially visible in this view, is the boat rental shed and bathhouse. (Courtesy of SMM Collection.)

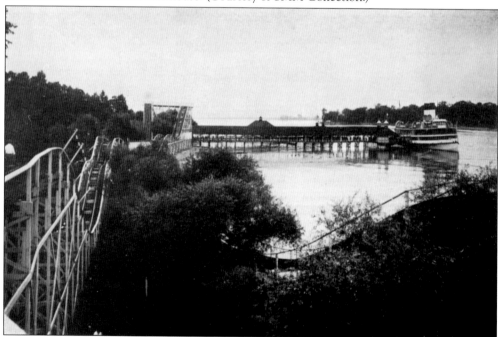

Arriving at Sugar Island. Many of the amusements were the same at both Tashmoo Park and Sugar Island—even to the point of the buildings' architecture. One major exception was the roller coaster, which was installed about 1908. The vessel in this view is the *City of Toledo*, newly enlarged and with her second stack. (Courtesy of SMM Collection.)

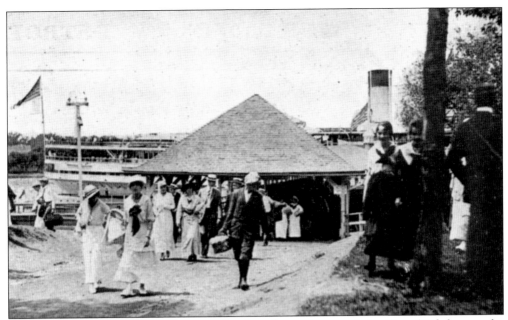

A Day at Sugar Island. The steamer *Greyhound*, seen here, and the *City of Toledo* were the usual boats on the Detroit-to-Toledo run, both stopping at Sugar Island. This island was the main rival for the Detroit, Belle Isle and Windsor Ferry Company's Bob-lo Island. (Courtesy of author's collection.)

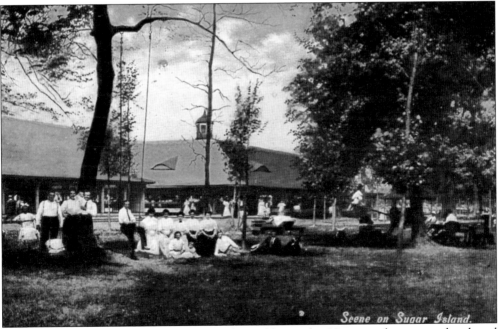

The Pavilion at Sugar Island. Thousands would visit the 30-acre park every weekend, and special charters would run to this dance pavilion for a late-night dance party. Older generations of people from Monroe and Toledo would remember Sugar Island just as generations of Detroiters remember Bob-lo Island or Tashmoo Park. (Courtesy of SMM Collection.)

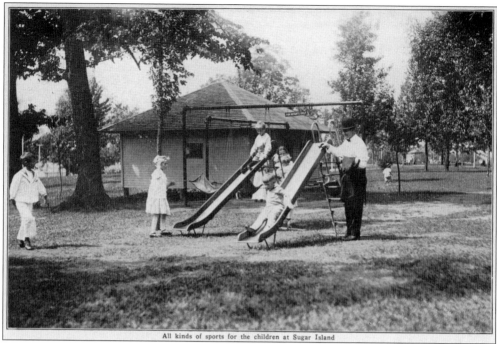

All kinds of sports for the children at Sugar Island

FUN FOR CHILDREN. Seen here in 1919, Sugar Island, like Tashmoo Park, always billed itself as a family park with games, rides, and accommodations suitable for women and young children. Both parks were dry—absolutely no alcohol was permitted on the premises. Rides for children, like these slides, were liberally spread throughout the park. (Courtesy of SMM Collection.)

THE PONY RIDES. The Shetland ponies and carts were a popular attraction at Sugar Island. Here, boys and girls could enjoy a ride at a slow pace on the island's gravel path until another amusement caught their eyes. This image is from 1916. (Courtesy of SMM Collection.)

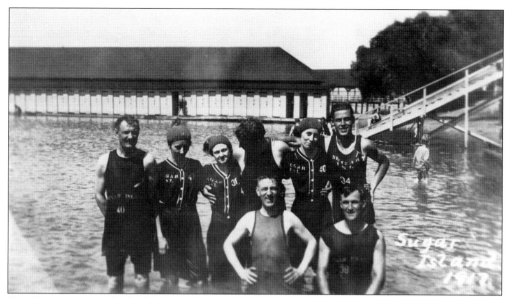

THE BATHHOUSE. The bathhouse formed a protected L-shaped lagoon, so mothers could watch their children at all times. The individual bathhouse rooms for changing, seen behind these swimmers, offered guests rentable bathing costumes for the entire day for just a few nickels. (Courtesy of SMM Collection.)

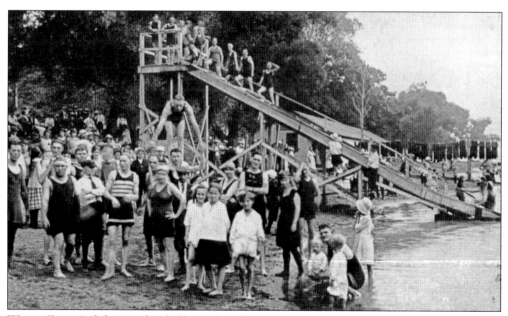

WATER FUN. A slide into the shallow inlet off Sugar Island provided hours of fun for young and old alike. Those wishing to swim but finding themselves without a bathing suit could rent one from the bathhouse custodian. (Courtesy of SMM Collection.)

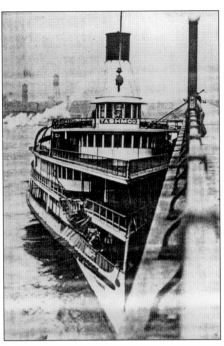

ACCIDENT AT BELLE ISLE. On December 8, 1927, a late-fall storm struck Detroit. The steamer *Tashmoo*, laid up for the winter, broke her steel mooring lines. She was blown upriver and was only stopped when she struck the new concrete Belle Isle Bridge. (Courtesy of SMM Collection.)

TOWED HOME. After brushing some other laid-up vessels on her trip upriver, the *Tashmoo* repeatedly slammed into the bridge until a pair of local tugs could be dispatched to capture her and return her home. Surprisingly, little significant damage occurred, and the steamer opened the 1928 season without any evidence of this adventure. (Courtesy of SMM Collection.)

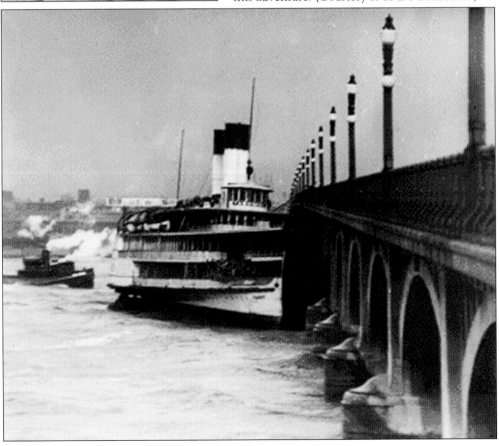

DOWNTOWN DETROIT. This view of Detroit's waterfront dates from the early 1930s, after the city's great downtown building boom of the late 1920s. In this photograph of the Griswold Street dock, the steamer has left for a trip up to the park. (Courtesy of Dossin Great Lakes Museum.)

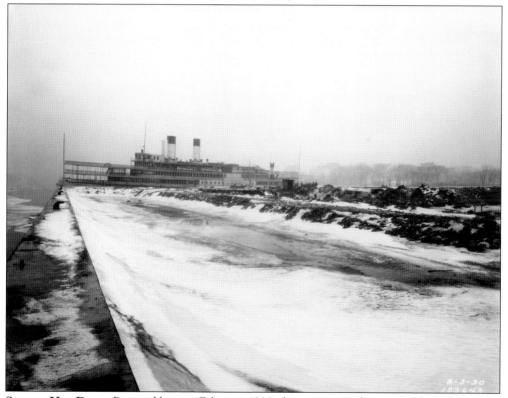

SAFE AT HER DOCK. Pictured here in February 1930, the steamer *Tashmoo* is safely tied up to her winter dock. The Great Depression had hit, and the economic outlook for the *Tashmoo* and her owners was as bleak as this winter landscape. (Courtesy of SMM Collection.)

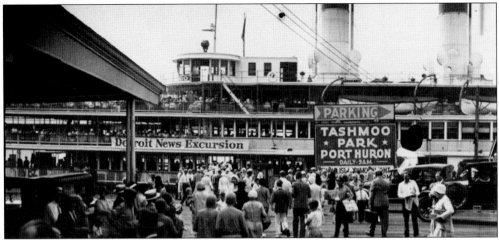

A Trip to the Park. During the Great Depression, the renamed White Star Navigation Company experienced a steady decline in business. Even the large corporate outings that the steamship line specialized in had fallen off significantly; however, there was still the annual *Detroit News* excursion, and passengers are seen boarding the *Tashmoo* for a ride to the park in July 8, 1932. (Courtesy of Reuther Library, Wayne State University.)

The Tashmoo is on its Way. It may have been the darkest days of the Depression, but who could repress a smile of anticipation while waiting for the famed *Tashmoo* to pull away from the dock and head upriver for a chance to forget one's troubles for at least a day? (Courtesy of SMM Collection.)

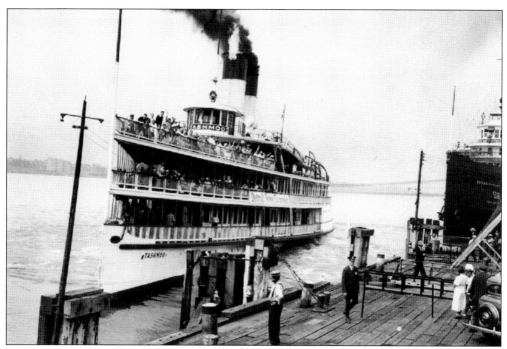

OFF AT LAST. The *Tashmoo* leaves her dock at the foot of Griswold Street, and the annual *Detroit News* excursion is underway. Although times are tough, it seems the steamer has a capacity load of passengers for this trip to Tashmoo Park. (Courtesy of Reuther Library, Wayne State University.)

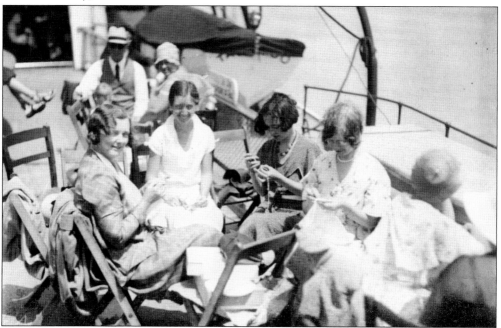

HEADING TO THE PARK. On this warm summer day, these ladies have shed their coats while enjoying some sunshine, good conversation, and knitting as the *Tashmoo* heads upriver during this annual *Detroit News* excursion. (Courtesy of Reuther Library, Wayne State University.)

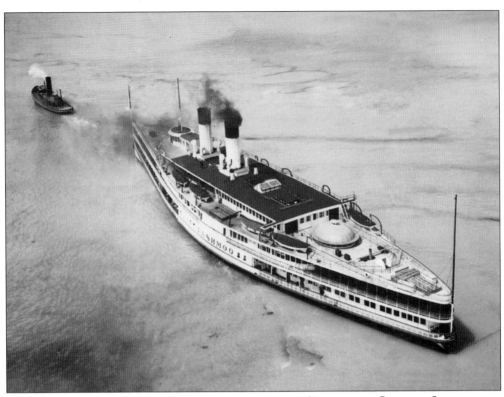

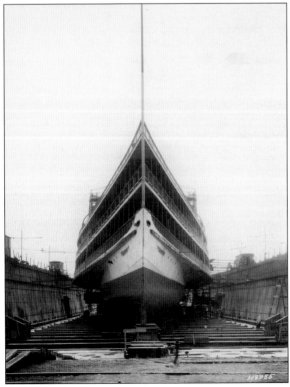

ACCIDENT AT SQUIRREL ISLAND.
On August 2, 1934, winds from a
summer storm drove the *Tashmoo*
over a sandbar off Squirrel Island
across from the entrance to Tashmoo
Park, damaging her port paddle
wheel. Tugs arrived to off-load the
passengers, who were then able to
reach Algonac and return to Detroit
by bus. The steamer is seen being
towed to the shipyard for repairs.
(Courtesy of SMM Collection.)

AT THE YARD FOR REPAIRS. The
Tashmoo was towed downriver to
the Great Lakes Engineering Works
(GLEW) in River Rouge. Once
in the shipyard's great floating
drydock, it was discovered that the
damage to the paddle wheel was a
bit more severe than first thought.
(Courtesy of Manning Brothers.)

REPAIRS UNDERWAY. The *Tashmoo* is seen here from the stern on August 10, 1934, while in the GLEW dry dock. Her damaged wheel is the one on the left, or port side, of this photograph. Although the damage was greater than initially estimated, the shipyard crew was able to complete the needed repairs in time for the steamer to sail within the week. (Courtesy of Manning Brothers.)

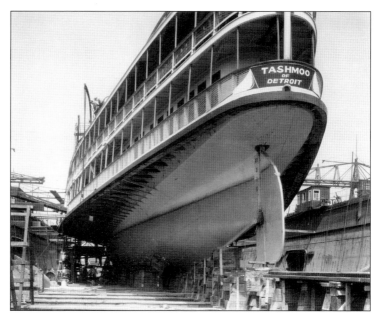

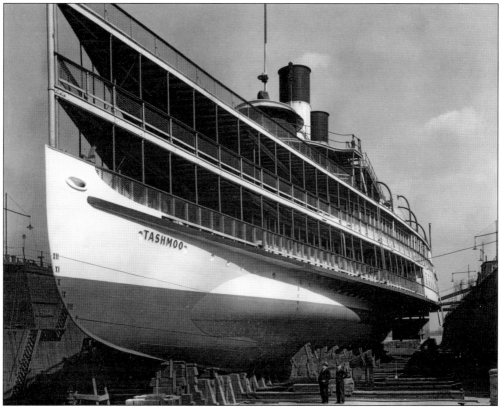

REFIT FOR THE TASHMOO. In April 1935, the steamer was back in dry dock for a major modification to her hull, giving her greater stability. Sponsons were added on each side of the ship, which looked very much like bulged-out blisters. The new port side sponson is clearly visible in this photograph. The work was successfully completed in just 17 days. (Courtesy of SMM Collection.)

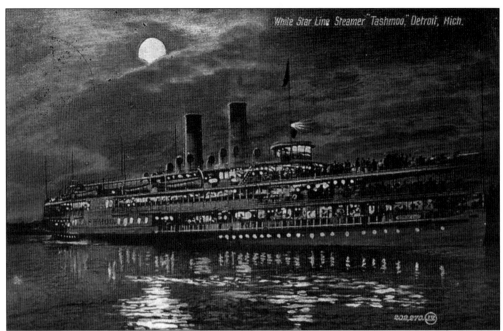

MOONLIGHT CRUISE. The *Tashmoo* was scheduled to begin her next season on June 23, 1936. However, before that date, she would begin her highly popular moonlight dance cruises. On the evening of June 18, 1936, the Pals Club of Hamtramck chartered the *Tashmoo* for a dance cruise downriver that included a short stop at Sugar Island. At about 11:30 p.m., just after leaving Sugar Island, the *Tashmoo* hit an uncharted underwater obstruction. She quickly began to take on water, but the crew was able to safely get her to a dock at Amherstburg. The 1,400 passengers were disembarked, loaded onto buses, and driven to Detroit without any knowledge of the seriousness of the accident. (Courtesy of Gary Grout.)

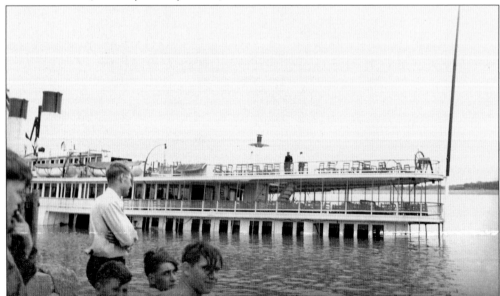

THE NEXT MORNING. This is the view that greeted the public the next morning: the *Tashmoo* sitting on the bottom of the river in 18 feet of water. (Courtesy of SMM Collection.)

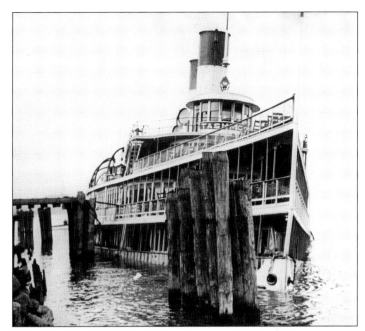

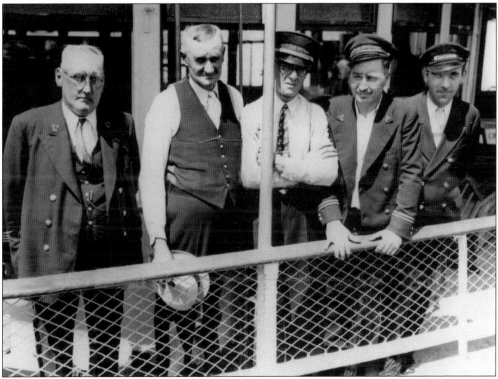

THE OFFICERS. The next morning, the officers gathered on the promenade deck forward as the story quickly spread throughout metropolitan Detroit that the beloved steamer had sunk. Pictured here, from left to right, are Capt. Don McAlpine, First Mate Walter Webster, Second Mate William Scherer, Second Asst. Engineer Alve Russell, and Wheelsman William Adamek. (Courtesy of SMM Collection.)

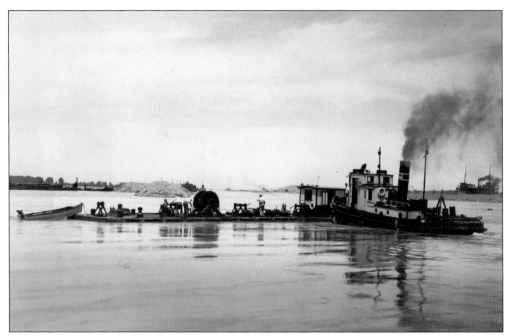

SEARCH FOR CAUSE. The damage to the ship's hull and keel was so significant, the US Army Corps of Engineers attempted to establish where and what the obstruction was and remove it. The search, however, was fruitless. The offending rock was never found. (Courtesy of SMM Collection.)

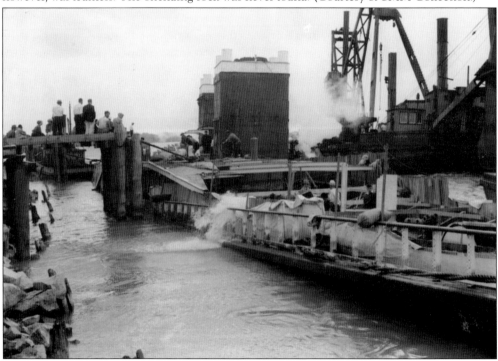

THE SALVAGE BEGINS. Crowds gathered each day and watched as the salvagers disassembled the vessel of all they could. Finally, all her furniture, fixtures, machinery, engine, and boilers were removed, and final raising of the hull and scrapping could begin. (Courtesy of SMM Collection.)

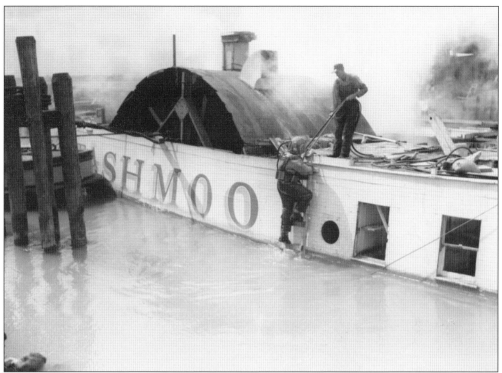

THE DAMAGE IS SERIOUS. A diver was sent down to survey the damage to the steamer, and it was discovered that a large section of the hull plating along the keel had been peeled back like a crudely opened sardine can. While it is commonly believed that the salvagers broke her back while lifting her, the *Tashmoo's* salvage was already a moot point before any operation began—they knew she would never sail again. (Courtesy of SMM Collection.)

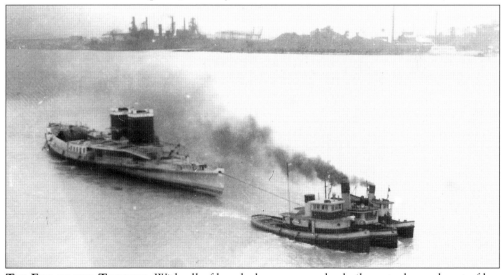

THE END OF THE *TASHMOO.* With all of her decks, upper works, boilers, stacks, and part of her engine gone, enough weight had been removed that, by the end of August, the hull could be patched and towed away to Nicholson's Marine Terminal. Eventually, the hull was cut up and sold as scrap. (Courtesy of SMM Collection.)

WHITE STAR ★ NAVIGATION CO.

TASHMOO TRANSIT CO., Lessee.

THE DETROIT-PORT HURON ROUTE

JOHN J. BARLUM . President.
C. F. BIELMAN, Jr. . . Vice-President and General Manager.
N F MacLEAN General Passenger Agent
C. B PERCY General Auditor.

General Offices—Foot of Griswold Street, Detroit, Mich.

The Beautiful S.S. "Tashmoo"

SERVICE DISCONTINUED FOR SEASON OF 1936

Daily, except Saturday, between Detroit and Port Huron.

		Eastern time.			
.
.	9 15 A M	lve.....Detroit.....arr.	7 50 P M
.	⊙..St. Clair Flats....		
.	11 45 A MTashmoo Park....	5 30 P M
.	12 10 P MAlgonac.......	4 50 P M
.	2 25 P MSarnia, Ont......	3 30 P M
.	2 30 P M	arr.. Port Huron ..lve.	3 20 P M

⊙St. Clair Flats Stops—Old Club, Club Aloha, Joe Bedore's. All flag stations—steamers stop on signal only or when passengers aboard wish to land. *July*, 1936.

SERVICE DISCONTINUED. In July 1936, this announcement was published in newspapers across southeastern Michigan. Service aboard the beautiful SS *Tashmoo* to the Flats, Harsens Island, Tashmoo Park, and Port Huron would be discontinued for the 1936 season. (Courtesy of SMM Collection.)

Five

THE LATER YEARS

Following the sinking of the *Tashmoo*, the White Star Line attempted to continue service to Tashmoo Park by chartering boats from other companies, but it was all in a losing effort. The combination of the loss of the steamer *Tashmoo*, the devastating effect of the Great Depression, and the difficult and uncertain times of World War II was more than the company could deal with. As attendance to the park plummeted, the owners tried a variety of solutions, even opening the park to customers arriving by automobile; however, nothing seemed to work, and after a series of intermittent closings, the park was permanently shut down in 1951. The park property was put up for sale but sat vacant for several years. Eventually, the old park property was purchased and turned into a marina. Some of the park's smaller buildings were moved while others were torn down. The old dance and casino pavilions were enclosed and converted for use for winter storage of pleasure boats. The days of the grand steamer and the lovely park were over. In 1997, the marina owners hosted a wonderful 100th anniversary party to commemorate the park. Several hundred guests attended, with many arriving on the excursion boat *Diamond Queen*. Many of the guests that day had visited the old park, and a few had even gone to the park on the steamer. All that is left of the park and steamer today are a couple of buildings, lots of pictures, and some wonderful memories.

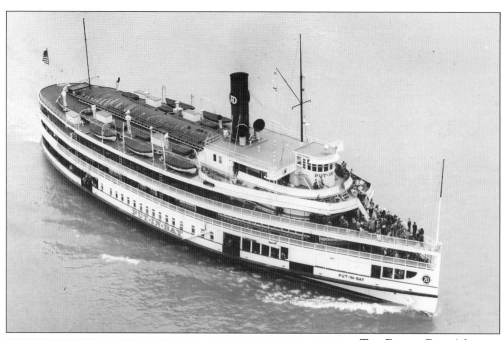

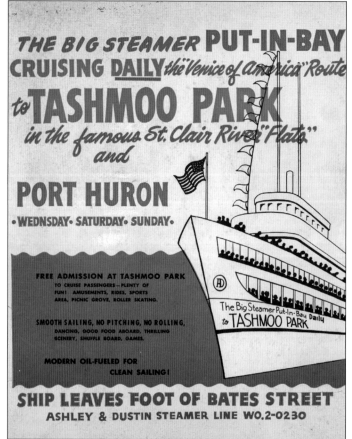

THE BIG STEAMER PUT-IN-BAY
CRUISING DAILY the "Venice of America" Route
to TASHMOO PARK
in the famous St. Clair River "Flats"
and
PORT HURON
• WEDNESDAY • SATURDAY • SUNDAY •

FREE ADMISSION AT TASHMOO PARK
TO CRUISE PASSENGERS – PLENTY OF
FUN! AMUSEMENTS, RIDES, SPORTS
AREA, PICNIC GROVE, ROLLER SKATING.

SMOOTH SAILING, NO PITCHING, NO ROLLING,
DANCING, GOOD FOOD ABOARD, THRILLING
SCENERY, SHUFFLE BOARD, GAMES.

MODERN OIL-FUELED FOR
CLEAN SAILING!

The Big Steamer Put-In-Bay Daily
to TASHMOO PARK

SHIP LEAVES FOOT OF BATES STREET
ASHLEY & DUSTIN STEAMER LINE WO.2-0230

THE PUT-IN-BAY. After the *Tashmoo* was lost, the White Star Steamship Company carried on for a number of years by chartering boats to provide service to Tashmoo Park. The most popular and frequently used of these boats was the *Put-in-Bay*. Built by the Detroit Shipbuilding Company, she was launched in 1911. Like the *Tashmoo*, she was designed by Frank E. Kirby. (Courtesy of Dossin Great Lakes Museum.)

THE BIG STEAMER. In an effort to reverse declining patronage to the park, the company carried on an active advertising campaign. This poster, promoting daily trips to Tashmoo Park by the *Put-in-Bay*, dates from 1951, the park's last season. (Courtesy of SMM Collection.)

WILLIAM AND MINNIE HARM. Park superintendent William Harm Jr. and his wife, Minnie, are joined by their daughter Dolores (or Dolly, as she was known) in the fall of 1945. The position of park superintendent was full-time, and the Harms lived year-round in a park-provided home at the back of the property. The house, shown in the background, survived until the early 1970s, when it was torn down. (Courtesy of Michele Komar.)

MINNIE HARM'S PASS. As had been the practice since the park opened in 1897, the park superintendent and his family were issued passes to travel on the steamers. This is the pass for Minnie Harm and her family for the 1940 park season. (Courtesy of Michele Komar.)

| 50 | 50 | 50 | 50 | 50 | 50 | 50 | 50 | 0 | 5 | 5 |

Not Transferable A & D *No.* **A** **65**

Value, $_____

Ashley & Dustin Steamer Line

To Mrs. Wm Harms & Family

Account Supt of Tashmoo Park

Not good after August_____

Purser will punch regular one way rates. Excursion rates do not apply.

O. J. Dustin.

GENERAL MANAGER

RAYMOND'S

TASHMOO PARK AUTO FERRY
AT ISLAND STOP ON M-29

Auto Ferry to Tashmoo Park and the Flats
Middle Channel and Bruckner's Island

**Oil-Burning Diesel Powered Ferries-Reducing
Fire Hazard to a Minimum**
NO GASOLINE -- SAFE AND SPEEDY

TELEPHONE ALGONAC 88

FERRY SERVICE TO HARSENS ISLAND. Regular ferry service to carry automobiles to Harsens Island began in the 1920s. When the main road on the island was paved in the mid-1930s, ferry service became more heavily used. Raymond's was one of the early ferry companies and, by the 1930s, was advertising expanded service to the island. (Courtesy of Michele Komar.)

SHALL WE TAKE THE FERRY? This view of the auto ferry *Raymond*, operated by the Raymond Ferry Company, provided regular service to Harsens Island. Once the ferry landed on the island, it was only a short five-minute drive to Tashmoo Park. (Courtesy of Michele Komar.)

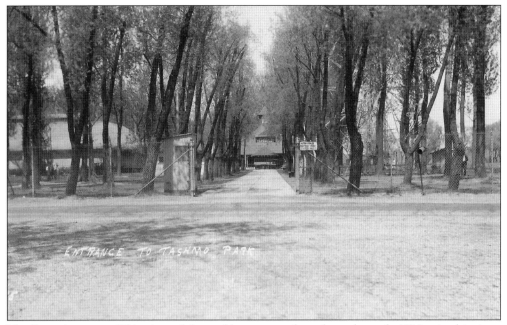

No Cars Allowed. This view of the park's entrance dates from the early 1930s. At this time, walk-in visitors were welcome, but cars were not. Note the sign that reads, "Automobiles Positively Must Keep Out." It would not be long, however, before this policy would change. (Courtesy of Gary Grout.)

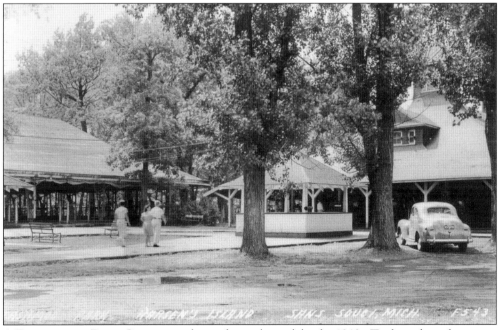

A Drive to the Park. Cars were welcomed into the park by the 1940s. To the right is the casino pavilion, commonly referred to as the cafeteria. To the left is the old dance pavilion. (Courtesy of Michele Komar.)

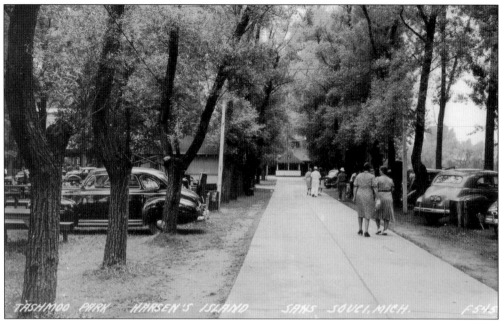

WE'LL TAKE THE CAR. By the late 1940s, the automobile was not only welcomed, but encouraged, as visitors to the park arriving by boat from Detroit was steadily declining. With concrete roads and regular ferry service, it was now an easy drive to Tashmoo Park. (Courtesy of Michele Komar.)

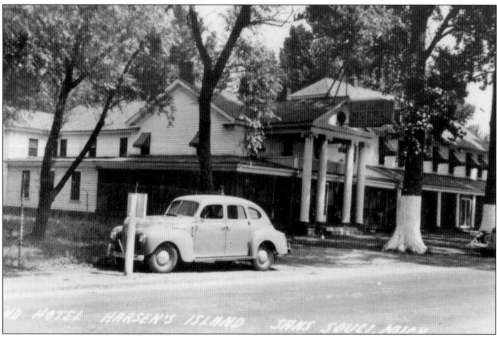

THE ISLAND HOUSE. One of the last operating hotels on Harsens Island was the Island House, seen here in the 1940s. Originally known as the Lemke Hotel, its name was changed when the owner, Walter Lemke, retired. Located near the town of Sans Souci, it was only a short walk to Tashmoo Park. In the spring of 1951, the Island House was destroyed by fire and never rebuilt. (Courtesy of Barb Crown.)

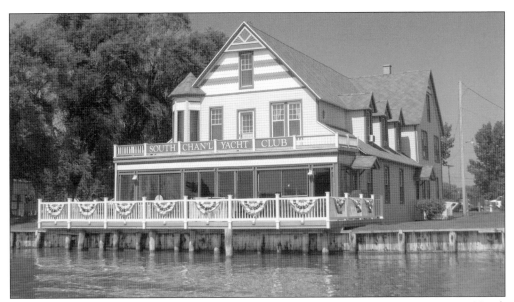

SOUTH CHANNEL YACHT CLUB. Built in the 1870s and known for years as Gus Trautz's Hotel, this building has been beautifully restored and is now part of the South Channel Yacht Club. This is a present-day view of the old landmark, which still has the brass numbers of the former hotel on the upstairs rooms. (Courtesy of Bernard Licata.)

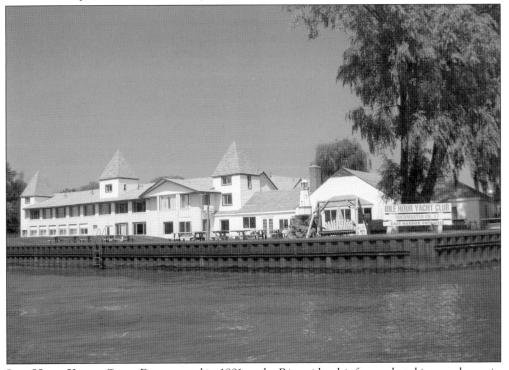

IDLE HOUR YACHT CLUB. First opened in 1891 as the Riverside, this former hotel is now the main building of the popular Idle Hour Yacht Club. During World War II, the government leased the property to use as a barracks. With its distinctive towers, this old hotel is a familiar landmark to boaters along the South Channel of the St. Clair Flats. (Courtesy of Bernard Licata.)

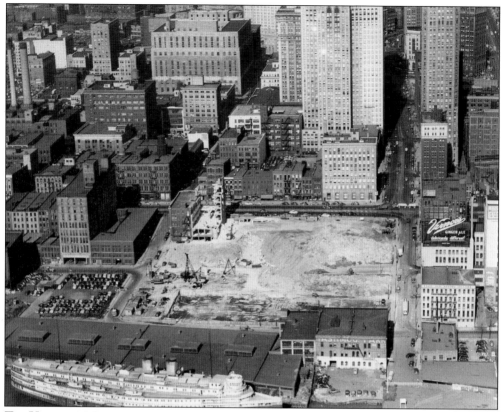

THE VETERANS MEMORIAL. Immediately after World War II, the city of Detroit began developing its long-planned waterfront civic center. The first land to be cleared was near the foot of Griswold Street. The old Tashmoo Park Dock (in the lower right) would soon be demolished, and the beautiful new Veterans Memorial Building would be constructed on this site. The old Detroit and Cleveland Navigation Company boat *City of Cleveland*, seen in the lower left of this image, would also soon be gone. (Courtesy of Manning Brothers.)

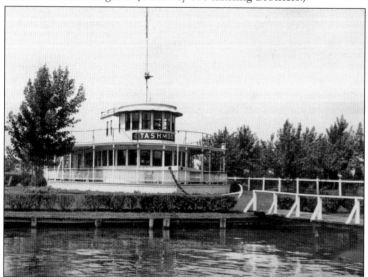

THE TASHMOO COTTAGE. When the steamer *Tashmoo* was scrapped, her pilothouse was saved and rebuilt as a private cottage near Chatham, Ontario. Sadly, this last piece of the famous excursion steamer was destroyed by fire on June 10, 1951. (Courtesy of Michele Komar.)

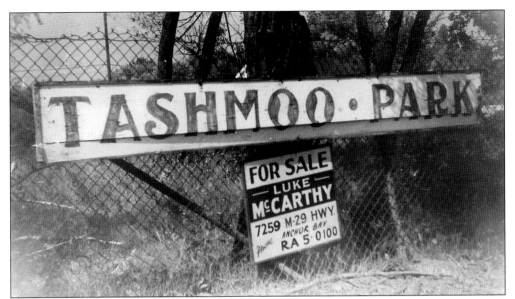

FOR SALE. After the loss of the steamer, the number of visitors coming to Tashmoo Park steadily declined. The park reverted to a fenced-in picnic grounds. Finally, in 1951, the park was closed, the gate was padlocked, and the property was put up for sale. (Courtesy of Bob and Susan Bryson.)

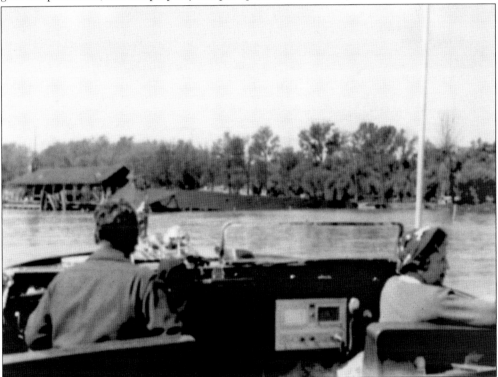

THE TUMBLED LANDING. In September 1953, a severe fall storm hit Harsens Island, destroying one of the last vestiges of Tashmoo Park. The landing and its distinctive two-cupola dock shelter collapsed into the river. Soon after this photograph was taken, the wreckage was removed, and another landmark was gone. (Courtesy of Peter Durand.)

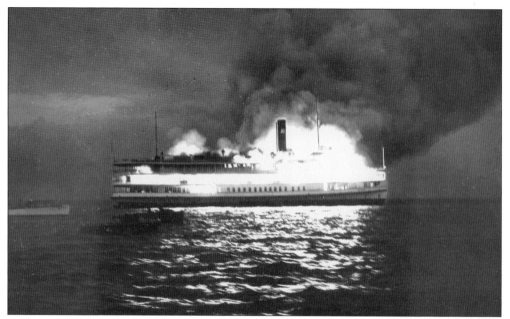

THE END OF AN ERA. The steamer *Tashmoo* was gone, the park was closed, and soon, the last excursion boat on the Detroit and St. Clair Rivers (except for the venerable old Bob-lo boats) would disappear too. The days of a pleasant ride up the river to the Flats and Tashmoo Park had finally come to an end. (Courtesy of Dossin Great Lakes Museum.)

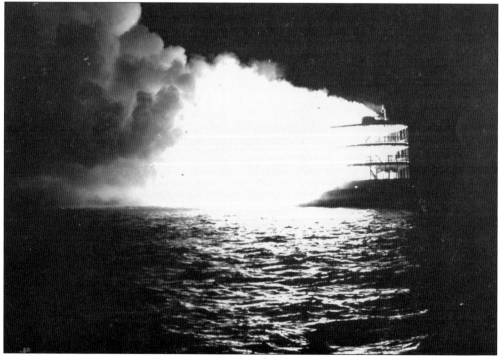

THE END OF THE *PUT-IN-BAY.* There were no passengers for the *Put-in-Bay*, so she sat tied up to her dock. Finding no buyer in need of a functioning steamship, she was sold at a sheriff's auction on May 6, 1953, to satisfy an outstanding loan obligation. (Courtesy of Dossin Great Lakes Museum.)

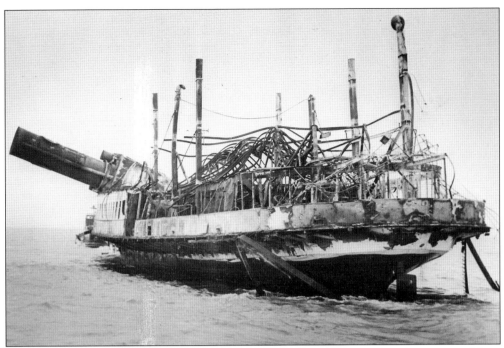

BURNED AS A SPECTACLE. To hasten the process of scrapping the *Put-in-Bay*, she was towed from her dock at Detroit out into Lake St. Clair and burned as a spectacle on the evening of October 4, 1953. This is all that was left the next morning. (Courtesy of Dossin Great Lakes Museum.)

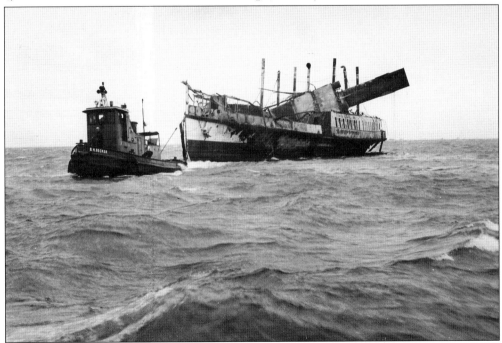

SOLD FOR SCRAP. In this view, the hull is being towed from Lake St. Clair. This burned hull was taken downriver to Windsor, Ontario, where she met the torch and was reduced to nothing but a memory. (Courtesy of Dossin Great Lakes Museum.)

A Plaque Unveiled. The old Tashmoo Park was finally sold and turned into a marina. In 1985, present owners Bob and Susan Bryson purchased the facility and further developed it. On July 3, 1997, in honor of the 100th anniversary of the park, the Brysons hosted a grand celebration that included the unveiling of an historical plaque by lifetime resident Dick Earl, seen here with Susan Bryson. (Courtesy of Bob and Susan Bryson.)

Awaiting the Guests. A fun-filled day was planned and offered a series of events for visitors young and old, including good food under this tent on the grounds of the old park. (Courtesy of Barb Crown.)

THE ARRIVAL OF THE DIAMOND QUEEN. One of the real highlights of the grand day was the arrival of the excursion boat *Diamond Queen* at the marina dock. One more time, 150 passengers could experience a day trip from Detroit, across Lake St. Clair, up the South Channel, past the Flats, and on to Tashmoo Park. (Courtesy of Bob and Susan Bryson.)

SOUND THE WHISTLE. As part of the day's activities, the old steam whistle from the *Tashmoo* was brought back to the park. Here, marina owner Bob Bryson, in one of the centennial sweatshirts with a logo specially designed by local artist George Crown, stands in front of a large tank of compressed air. Atop the tank is the steamer's whistle, which was sounded much to the delight of all in attendance. (Courtesy of Bob and Susan Bryson.)

THE PARK BUILDINGS. Today, all that remains of the old park are some of its original structures, such as the casino pavilion with its distinctive cupolas. To the left is the dance pavilion, and in the foreground is a small building that is believed to have housed park athletic equipment. (Courtesy of author's collection.)

ATHLETIC EQUIPMENT BUILDING. This small building is thought to be the structure where park athletic equipment was stored. Here, park visitors would stop to get, amongst other supplies, balls and bats for baseball games. The structure was moved from its original location to this site by the first marina owners. (Courtesy of author's collection.)

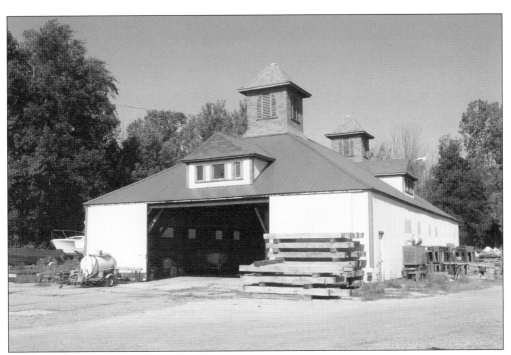

CASINO PAVILION. Today, the still distinctive casino pavilion stands on its original site. Although now enclosed, the cupolas and dormers are easily recognized. Note the building's original wooden beams on each side of the open entrance. (Courtesy of author's collection.)

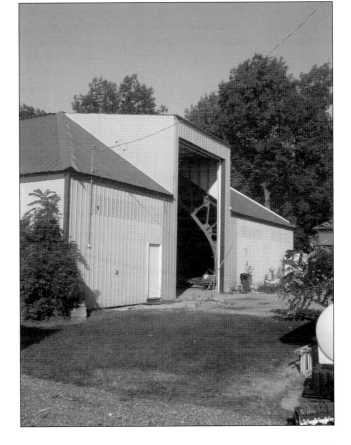

DANCE PAVILION. Like the casino pavilion, the old dance pavilion has been enclosed and is now used as a boat storage facility. Supporting the structure, the original iron beams can be seen through the open doorway. (Courtesy of author's collection.)

A NEW ROOF. Several years ago, the old dance pavilion, now a storage facility for pleasure boats, needed a new roof. The old shingles had deteriorated to the point where they needed to be replaced. Here, crews are seen installing a new metal roof. At the right near the open entrance, one of the original iron roof support beams can be seen. (Courtesy of author's collection.)

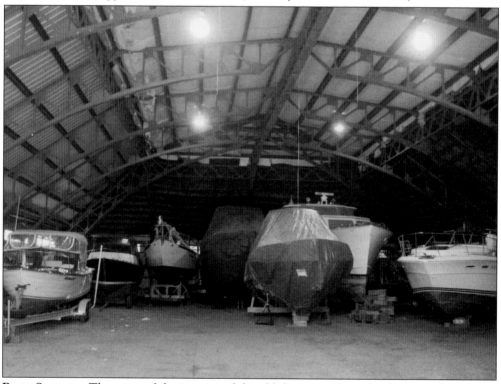

BOAT STORAGE. This view of the interior of the old dance pavilion clearly shows the interior structure of the original building. Sadly, the original wooden dance floor has been replaced by concrete, and the old dance pavilion will soon be filled with yachts and sailboats of all sizes stored for the winter. (Courtesy of author's collection.)

THE NEW LANDING. Here is a photograph of the Tashmoo Marina dock taken from the river. Although much has changed, vestiges of the old park remain. At the far end of the dock and entrance, the old casino pavilion can be seen, and just above the trees and to the left is the roof of the old dance pavilion. There is one very notable change, however. Rising over the line of trees behind the old casino pavilion is a 21st-century cell phone tower. (Courtesy of author's collection.)

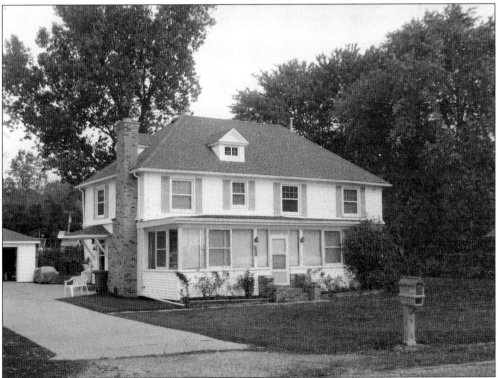

THE PARK OWNER'S HOUSE. Tashmoo Park was purchased by brothers Peter and Arlington "Arley" Fleming in 1943. Arley moved this building, the former nursery, to the front of the property, remodeled it, and used it as his home. Today, the beautifully restored house is a private residence. (Courtesy of author's collection.)

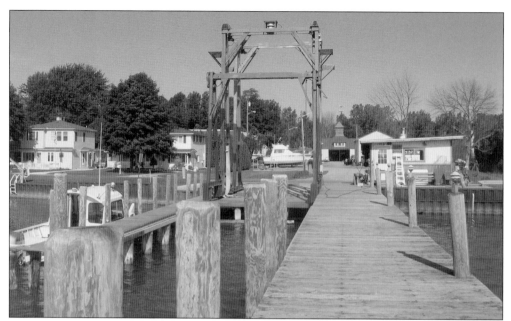

THE LANDING TODAY. Although much has indeed changed, this view of the landing would still be familiar to park guests from 100 years ago as they disembarked from the steamer *Tashmoo* and hurried along the dock looking forward to a fun-filled day at Tashmoo Park. (Courtesy of author's collection.)

THE GROUNDS TODAY. Today, little remains of the beautiful grounds of the old park. Gone are the baseball diamonds, the merry-go-round, the picnic grove, the souvenir stands, and the swings and benches where city-dwellers could enjoy a pleasant day at Tashmoo Park. (Courtesy of author's collection.)

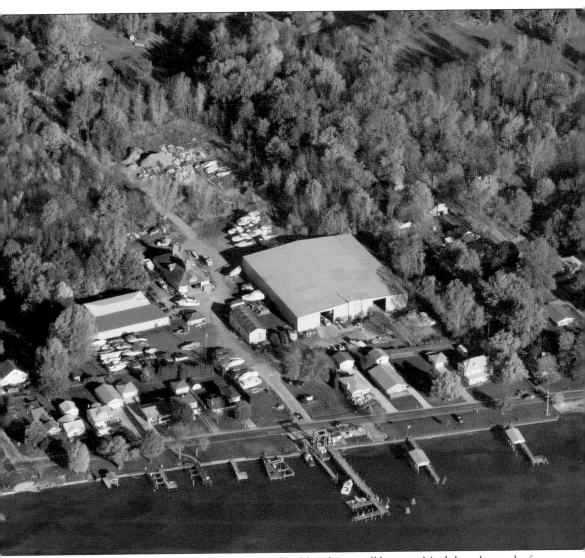

THE PARK TODAY. Viewed from the air, parts of the old park can still be seen. Much has changed, of course. Year-round homes and summer cottages are now visible, but so are the old casino and dance pavilions and, in the lower right of this image, the old park owner's house. Tashmoo Park and the steamer *Tashmoo* may be gone, but many great memories remain. (Courtesy of Pete Dorand.)

DISCOVER THOUSANDS OF LOCAL HISTORY BOOKS
FEATURING MILLIONS OF VINTAGE IMAGES

Arcadia Publishing, the leading local history publisher in the United States, is committed to making history accessible and meaningful through publishing books that celebrate and preserve the heritage of America's people and places.

Find more books like this at
www.arcadiapublishing.com

Search for your hometown history, your old stomping grounds, and even your favorite sports team.

Consistent with our mission to preserve history on a local level, this book was printed in South Carolina on American-made paper and manufactured entirely in the United States. Products carrying the accredited Forest Stewardship Council (FSC) label are printed on 100 percent FSC-certified paper.

MADE IN THE